IMAGES
of America

SAN FRANCISCO'S
PANAMA-PACIFIC
INTERNATIONAL EXPOSITION

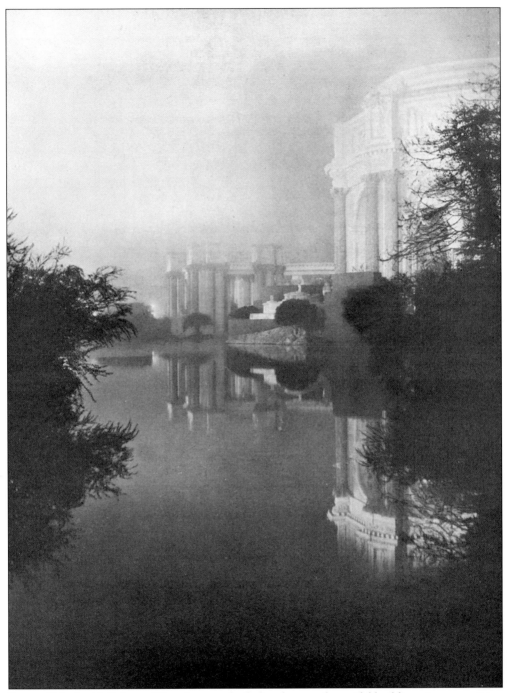

Bernard Maybeck's Palace of Fine Arts was hailed as the most beautiful building at an exposition that was lauded world-wide for its architecture. Designed to evoke a "sense of sadness modified by the feeling that beauty has a soothing influence," it immediately became and has since remained one of San Francisco's most beloved landmarks, the only exhibit hall to survive the end of the fair.

IMAGES
of America

SAN FRANCISCO'S
PANAMA-PACIFIC
INTERNATIONAL EXPOSITION

Dr. William Lipsky

ARCADIA
PUBLISHING

Published by Arcadia Publishing
Charleston, South Carolina

Printed in the United States of America

Library of Congress Catalog Card Number: 2005924869

For all general information contact Arcadia Publishing at:
Telephone 843-853-2070
Fax 843-853-0044
E-mail sales@arcadiapublishing.com
For customer service and orders:
Toll-Free 1-888-313-2665

Visit us on the Internet at www.arcadiapublishing.com

For Don, Larry and Shelly, Theodore, Polly, and Sam.

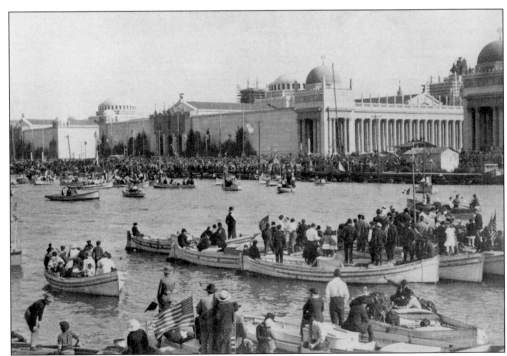

Built for the PPIE, the Marina District's Yacht Harbor was a gift to San Francisco from the fair.
Its first grand event was the Columbus Day celebration of 1914, four months before the fair
itself opened, when members of the Fraternal Order of Red Men greeted the Nina, Pinta, and
Santa Maria at the entrance to the Court of the Universe.

CONTENTS

ACKNOWLEDGMENTS

The images on pages 127 and 128 are courtesy of Donald Price and used with kind permission.

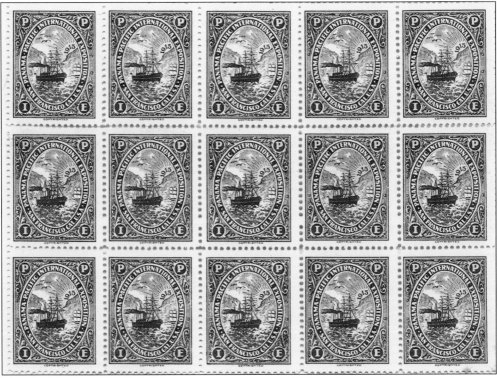

The exposition took every opportunity to promote itself from the very beginning, using press releases, postcards, preview booklets, and poster stamps—then extremely popular. Issued in sheets and given away or sold for nominal amounts, dozens of varieties exist. In this sheet of 1915 stamps, the rising sun glows just inside the Golden Gate.

INTRODUCTION

It was the most opulent American exposition ever held west the Mississippi, the last of the classic world's fairs. Less than nine years after the great earthquake and fire had devastated the city, San Francisco hosted the Panama-Pacific International Exposition (PPIE). More than 18 million people attended.

San Franciscans had discussed the possibility of holding a great exposition to celebrate the opening of the Panama Canal as early as 1904, before the United States had official permission from Panama to build it. The twin catastrophes of 1906 seemed to end all possibility of hosting a world's fair any time soon, if ever, but the proposal was revived and given serious consideration in 1909. By then, a half-dozen cities had entered the competition to win official government recognition for themselves.

The odds against San Francisco having the exposition were formidable, but the City conducted a two year public-relations and lobbying campaign that ended with it being awarded the fair. Success was not guaranteed, however. Remaining obstacles were political, legal, financial, social, and, unexpectedly, military.

Once a location was selected, the exposition had to reach agreements with some 175 private land owners and with municipal, state, and federal authorities. It then needed to get permission to charge admission to public lands; to construct buildings and sanitation facilities that violated the building ordinances; to reach an accord between management and labor that, among other issues, allowed foreign workers to construct foreign pavilions and exhibits; to suspend the tariff on imports to the fair; let contracts; invite state and foreign participation; and to attract enough visitors to be financially successful—all within less than four years, two years of which was spent planning and preparing.

Actual construction at the fairgrounds began in January 1913, when the first building contract was let. Within two years, the exposition turned 625 acres of landfill into a beautifully landscaped wonderland with 11 enormous exhibition palaces, dozens of state and foreign pavilions, and an amusement zone almost a mile in length. Additional new construction included an aviation field, a drill ground, a center for livestock, and a racecourse. It commissioned and installed several hundred statuary groupings and scores of murals, many by the most noted artists of the day. In all, it spent more than $25 million to display some $50 million worth of exhibits. Unique among American world's fairs to that time, it opened on time and completely ready.

Planners of the exposition overcame many obstacles, completed construction in record time—sometimes months before the fair opened officially to the public. Then it experienced

one final, unexpected crisis: the beginning of the Great War in Europe, which threatened to prevent both foreign participation and foreign visitors. Some countries cancelled, and many people abroad were unable to come, but neither daunted the fair's triumph.

Celebrating the construction and opening of the Panama Canal, the greatest technological achievement of the era, the exposition maintained its themes of human progress through human endeavor and accomplishment. "Civilization here bursts abloom with every promise of the first fruitages," said Vice Pres. Thomas Marshall when he visited, and most agreed. Even the grim news from the war in Europe did not vanquish the fair's positive outlook.

Manifestations of progress were everywhere at the exposition. Among other wonders, the fair was the first to receive a transcontinental telephone call, the first to exhibit a periscope in the United States, the first to exhibit a million-volt electric transformer, the first to demonstrate steam pyrotechnics, the first to use indirect lighting, the first to use colored lighting, the first to use trackless streetcars, the first to have a working automobile assembly plant on the ground, and the first to offer airplane rides to the public. Who could doubt that even more amazing inventions for the benefit of humanity were sure to come?

The fair was a resounding success. It attracted more than 18 million people; made a profit; left lasting memories with those who attended; and contributed enduring benefits to the social and cultural richness of San Francisco with a civic auditorium, artwork, recreation facilities, and a permanent landmark—the Palace of Fine Arts—beloved by generations.

The exposition celebrated the successful completion of the Panama Canal, the greatest engineering feat of its day. At a cost of $352 million—and 5,600 lives—it was then the largest peacetime expenditure in American history. The federal government had spent about one-fifth as much to purchase all new territories to that date—Louisiana, Florida, western lands taken from Mexico, Alaska, and the Philippines. The Culebra, or Galliard Cut, presented the most difficult construction of all, requiring 40,000 tons of dynamite.

One

THE BATTLESHIP
AND THE CANAL

Battleships often begin wars. Occasionally, they end them. Sometimes, in the service of their country, they destroy great public works—and the cities where they stood—but only rarely do they engender them. Instrumental in bringing about the building of the Panama Canal, the greatest engineering feat of its generation, the accomplishment of the USS *Oregon* is unique in American history.

The dream of a great waterway connecting the Atlantic and Pacific Oceans across the isthmus of Central America dates back to at least 1513, when Vasco Nunez de Balboa stood "silent, on a peak in Darien," having just completed his trek through jungles, swamps, inhabitants, and difficult mountain terrain. Nothing much was done about it, however, until 1881, when Ferdinand deLessups, builder of the Suez Canal, started construction of a similar canal in Columbia's northernmost province, Panama. His company went bankrupt in 1899, but by then the USS *Oregon* had vividly demonstrated to the American public their need for the canal.

At the beginning of the Spanish-American War, the *Oregon* was ordered from the West Coast to Cuba. Her journey around South America, one of the most famous in United States naval history, took 67 days, which graphically and concretely "showed the need" for a shortcut between the Atlantic and Pacific Oceans—and solidified the United States' determination to build one.

Without trying to place an altruistic fig leaf on a naked martial truth, George Goethals, in charge of the project, wrote, "Our primary purpose in building the Canal was not commercial, but military, to make sure that no battleship of ours would ever have to sail around South America, as the *Oregon* did, in time of war." The battleship's voyage was the deciding factor.

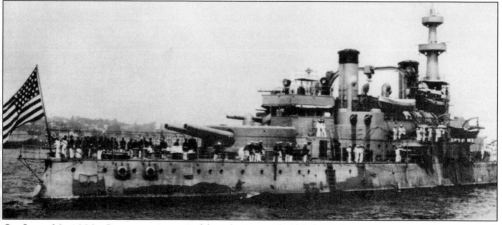

On June 30, 1890, Congress approved legislation to build three "seagoing coastal battleships." Two were to be built in Philadelphia, but the USS *Oregon*, the greatest of them all, would be built in San Francisco at a cost of more than $4 million.

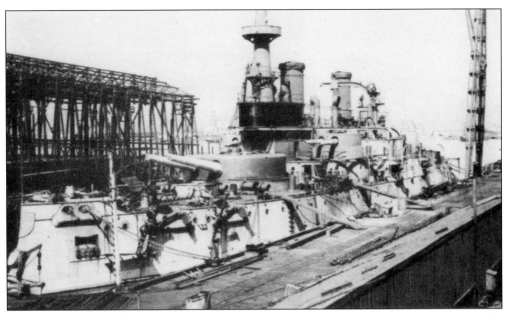

The Union Iron Works in San Francisco laid the keel for the USS *Oregon* on November 19, 1891, and she was launched on October 26, 1893, with appropriate pomp, prayers, and poetry. More than 100,000 people witnessed the occasion. Fitting out the ship took almost another three years, but she was finally ready for sea trials in March 1896, when this photograph was taken.

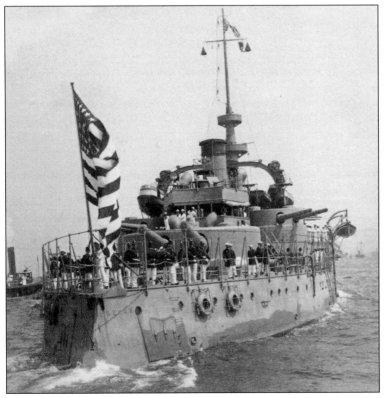

When the *Oregon* was commissioned on July 15, 1896, she was San Francisco's pride, the largest, most powerful American fighting ship built to that date. Within two years, she would become one of the most famous ships in American history.

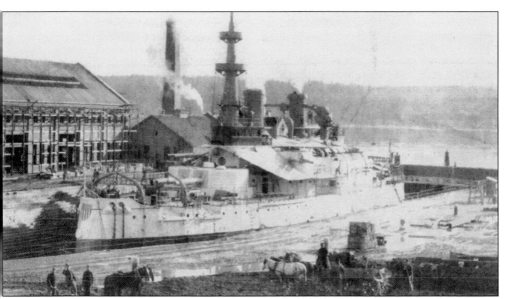

Following her commissioning ceremonies, the *Oregon* made her first sea voyage, not returning to San Francisco until February 1897. That fall, she received orders to journey to the Puget Sound Naval Station, where she arrived in January 1898, when this photograph was taken.

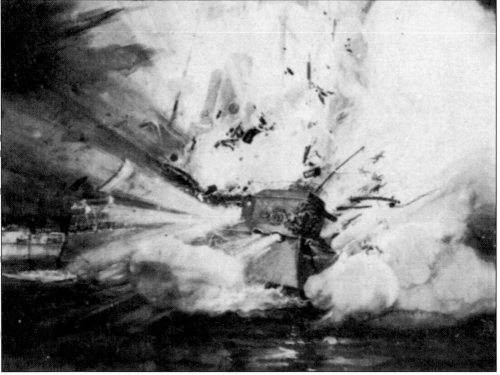

When the USS *Maine* blew up in Havana Harbor on February 15, 1898, the *Oregon* was ordered back to San Francisco, but she did not leave immediately. Because of the Klondike gold rush and the large number of commercial ships taking people and equipment to and from Alaska, she could not obtain enough suitable steam coal to make the trip.

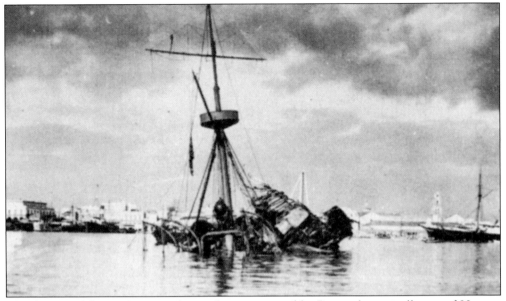

The demise of the *Maine* seemed to make war inevitable. Rising dramatically out of Havana Harbor, the mast of the martyred ship reminded all who saw it that here was simply a struggle of freedom over tyranny, America seeking no gain in Cuba for itself, only the liberation of an oppressed Cuban people. Simultaneously, it freed Puerto Rico and the Philippines for its own colonial empire and annexed Hawaii.

The *Oregon* returned to San Francisco on March 9, 1898, then left for Jupiter Inlet, Florida, some 13,675 nautical miles away around the Cape of Good Hope. Her 13-inch breech guns made her a formidable adversary, but the journey took over nine weeks, continuously reported by the country's newspapers to a nervous public. Could she arrive in time? Was there not a more timely way to respond to an approaching foreign invader?

Dispatched from Florida to Cuba, the *Oregon* saw action in the Battle of Santiago, where she caused the *Cristobal Colon*—the fastest ship in Spain's squadron, to run ashore—thereby disabling about one-fifth of the enemy's fleet. The success of her crew was duly honored, but it was her difficult and often daring journey from California to Florida that captured and held the public's attention.

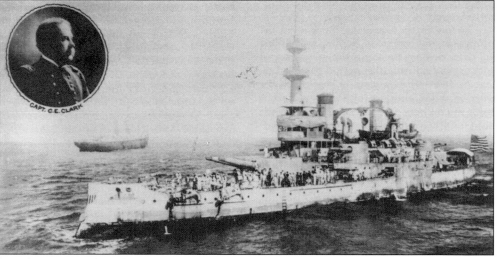

By July 4, 1898, when this photograph was taken, the *Oregon* was one of the two most famous ships in the American fleet. The other, Adm. George Dewey's flagship *Olympia*, also built at San Francisco's Union Iron Works, is now the sole surviving warship of the Spanish-American War and the third oldest American naval vessel still in existence. The inset shows Capt. Charles Clark.

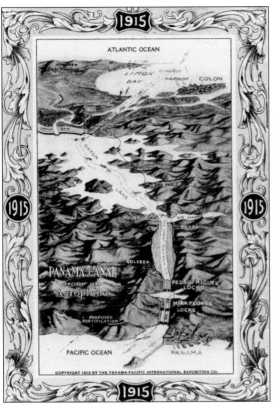

Because of the *Oregon's* heroic voyage, the American public saw, for the first time, the impossibility of safeguarding its coastlines without dividing its navy into two separate fleets, each unable to support the other in an emergency. The Canal Commission, appointed to determine a path for an engineered waterway across Central America, stayed closely with the French route, although the canal finally built would not use their sea level design.

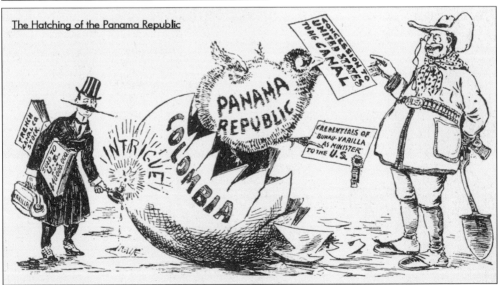

After receiving the commission's report, Pres. Theodore Roosevelt began negotiations with Columbia in 1903 for the right to build a canal across its northern province. The Columbian government eventually rejected American demands, so Roosevelt vowed to achieve his objective by force, if necessary. He did just that a few months later, first encouraging a rebellion in Panama, then preventing Columbian troops from landing to crush it, and finally recognizing Panama's independence.

Roosevelt quickly came to realize that no private corporation could overcome the enormous obstacles to success: the immense amount of capital needed to do the job, and the poisonous environment in which the work would take place. Given the region's steep and forbidding terrain, wasting humidity and torrential seasonal rains, vermin, and deadly diseases, the 50-mile strip between the oceans easily justified the name "Death's Dominion."

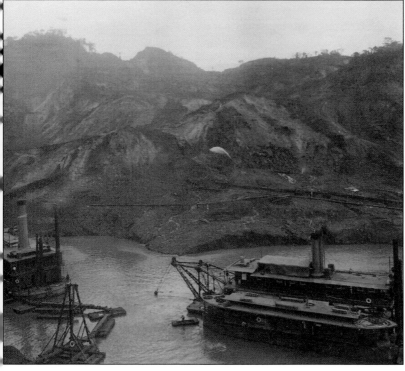

Roosevelt wasted no time starting the construction project, which required hundreds of locomotives, thousands of railway cars, dozens of cranes, pile drivers, barges, launches, steam shovels, and tugs. Of the 20 or so dredges used on the project, 2 are seen here.

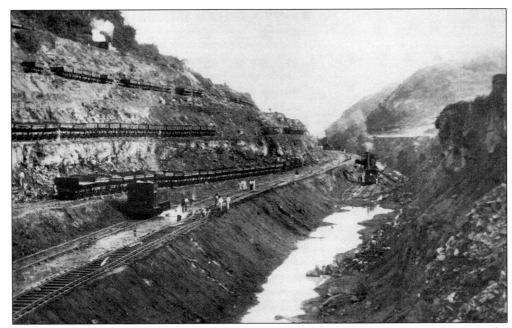

The United States learned from the experience of the French. As a government project, the American venture gained essentially unlimited funding and unlimited support. Rejecting a sea-level canal for one using a system of locks, it reduced the amount of excavation by two-thirds, shortening the construction time by decades. Eradicating yellow fever in the Zone, which killed more than 30 percent of the work force between 1881 and 1889, eliminated the human tragedy that finally destroyed the French project. Although the Isthmian Canal Commission initially dismissed the scientific evidence about a yellow fever–mosquito connection as "balderdash"—and rejected proposals to the destroy mosquito breeding grounds—Roosevelt eventually overruled their decision. By the time the canal opened in 1914, the death rate from yellow fever in Panama was half that of the United States.

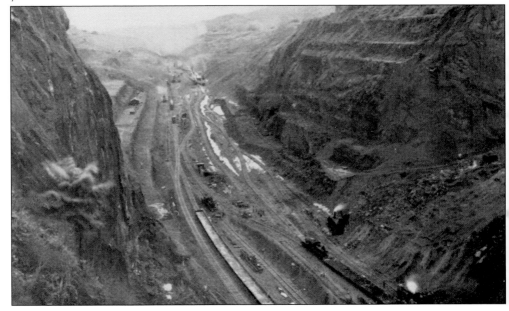

During its construction, the canal became a favored tourist destination, the difficult Culebra or Galliard Cut an especially popular stopping-off place. The unwanted rock and dirt was moved at a rate of 4,000 cubic yards a day to form Gatun Dam, 24 miles away.

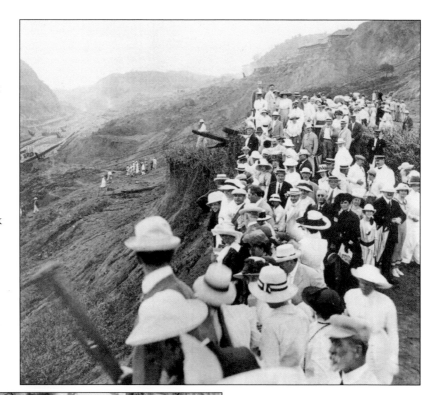

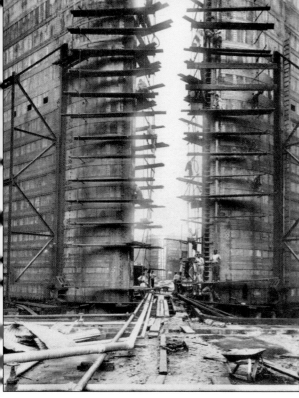

The canal's Gatun Locks were an engineering marvel all by themselves. Each one a thousand feet long, 110 feet wide, and 81 feet high, they were separated from each other by enormous steel gates, 65 feet wide and from 47 to 82 feet high. Of the canal's 12 locks, 6 were part of the Gatun complex.

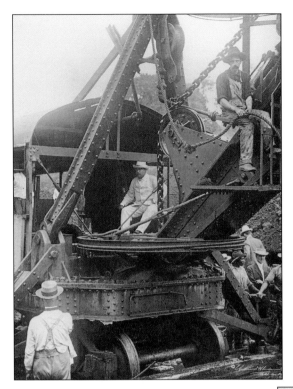

President Roosevelt did more than play tourist when he visited the canal in 1906. He was the first president to leave the country while in office. A master of the photo opportunity, he soon found himself in the cab of a 95-ton Bucyrus steam shovel, moving soil and rock to a waiting railcar. Although his light, linen suit was appropriate to the climate, full-time workers dressed more casually.

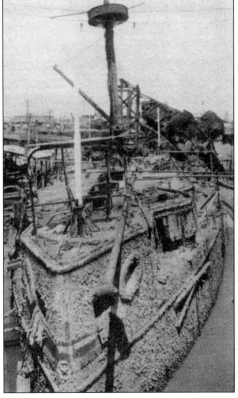

In 1912, 14 years after it sank in Havana Harbor, the battleship Main was raised, towed out to sea, and then sunk with great ceremony and honor. By then, the Panama Canal was well under construction, as was the exposition to celebrate its completion.

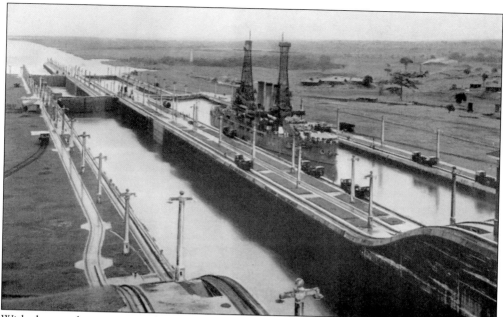

With the canal nearing completion, 60,000 Portland schoolchildren petitioned Pres. Woodrow Wilson to let the USS *Oregon* be the first through the Panama Canal on opening day. Wilson agreed, but the Great War in Europe ended the planned celebration; a cement boat became the first to officially traverse the new waterway. Here, the USS *Ohio*, on its way to the Panama-Pacific Exposition, presents a much nobler picture.

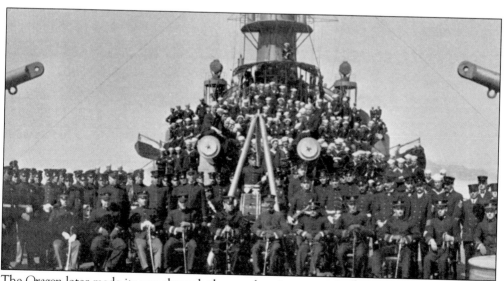

The *Oregon* later made its way through the canal on its way to the Panama-Pacific Exposition, where this photograph of a grand reunion of her veterans was taken. The ship remained in San Francisco Bay (where she began) almost the entire time the fair was open. She was visited by thousands of citizens grateful for the key role she played in bringing about the Panama Canal and giving the exposition its reason to be.

1915

The President and Board of Directors of the

Panama-Pacific International Exposition

Beg to inform you

that the Exposition celebrating the completion of the

Panama Canal

will be opened to the public with appropriate ceremonies

Saturday, February twentieth, nineteen hundred fifteen,

in accordance with the Act of Congress and

the Proclamation by the President of the United States.

The Exposition will on that day be complete

in every detail including the participation of the nations

of Europe, of the Orient and of all the Americas.

Very cordially yours,

Chas. C. Moore,

President.

The Pan-Pacific was the first world's fair to be fully ready for visitors on its announced opening day. In truth, because of the war in Europe, not every exhibit had arrived, but all the great halls, pavilions, facilities, and landscaping were finished. Some of it—the yacht harbor, for example—had been completed months earlier.

Two

THE CITY THAT KNOWS HOW

On January 12, 1904, local department store owner Reuben Hale wrote to the other directors of the San Francisco Merchants' Association, asking their views about an idea of his. "Our foreign possessions have centered the eyes of the world upon San Francisco," he stated. "Is not the time ripe," he wondered, "for us to consider a world's exposition in San Francisco in 1915" to celebrate the opening of the Panama Canal?

Hale's proposal made good business sense. "The greatest World's Fair ever attempted," he argued, would be the greatest promotion possible for San Francisco; bring millions of dollars into the city; and even more importantly, position San Francisco as the essential seaport on the new, lucrative trade routes between the Atlantic seaboard and Asia.

At a quickly organized meeting, the directors of the Merchants' Association invited the leaders of San Francisco's commercial and manufacturing groups to explore the proposal. The outcome: a joint resolution recommending that the city host a "Pacific Ocean Exposition," its board of directors to be made up of the presidents of the organizations represented at the meeting. No one seemed concerned that there was not yet a canal and might never be one; if necessary, they would instead celebrate the 400th anniversary of Balboa's 1513 trek across the Isthmus of Panama.

The business community now behind the proposal, all San Francisco needed to do was get official recognition from Washington; raise about $25 million; suspend, repeal or change numerous federal, state, and local laws; find a suitable site within the city limits; enroll as many exhibitors and concessionaires as possible; overcome formidable obstacles not yet existing and impossible to have imagined, including earthquake, fire, and war; and complete the work by opening day if, in fact, there ever would be an opening day—or even a Panama Canal.

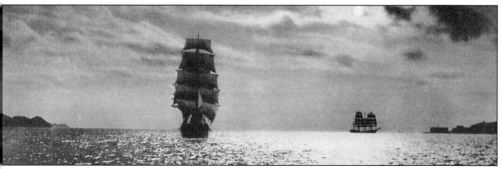

The Golden Gate received the romance, but San Francisco's port made it an ideal choice to host an exposition honoring the world's newest shipping routes. In 1904, it was one of the busiest commercial seaports in the world, handling 29 percent of American business with China, 27 percent with Japan, and 48 percent with Hawaii. Among related enterprises, it had a thriving shipbuilding industry and was the world's leading whaling port.

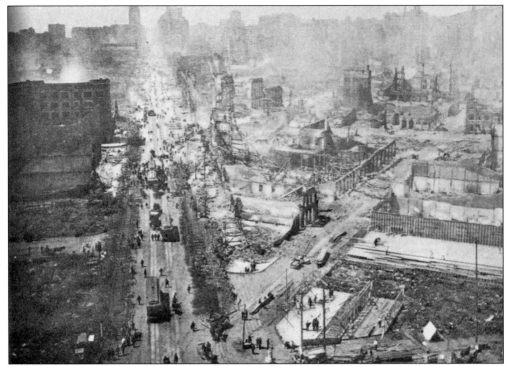

Before the exposition committee had gotten very far, the Great Earthquake and Fire of 1906 seemed to doom the enterprise forever. This photo looks west on Market Street from the Ferry Building. The city's entire business district was in ruins, as was its civic center and most of its infrastructure. The question, "Should San Francisco host a world's fair?" seemed ridiculous next to, "Could San Francisco ever recover?"

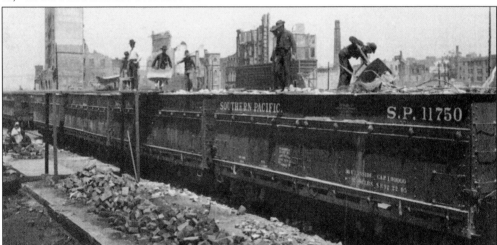

Urban legend has it that the debris from the Great Earthquake and Fire was first gathered up, then carted to Harbor View, which adjoined the Presidio, to create landfill for the Panama-Pacific Exposition. This was not the case, however. Everything that could be salvaged was reclaimed for future use. Everything else was shipped out of the city by ship or railcar. None of it was dumped on the north shore. At the time, no one knew if San Francisco would ever be able to host an exposition, much less where it would be.

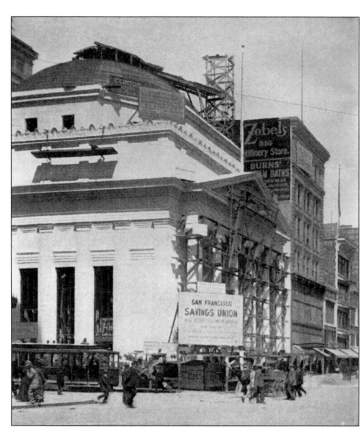

More than a few people believed it would take the city decades to recover.

By 1909, however, San Francisco's reconstruction had been nothing less that miraculous. Some buildings, including the San Francisco Savings Union (right), now a clothing store, at Grant and O'Farrell were still receiving their final touches, but the area in and around Union Square, Geary Street (lower left), much of Market Street (lower right), and most of the financial district had been rebuilt.

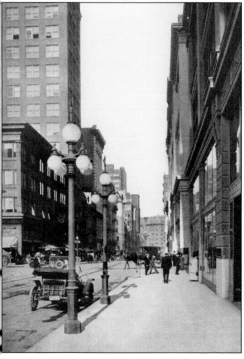

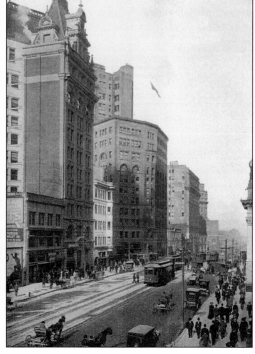

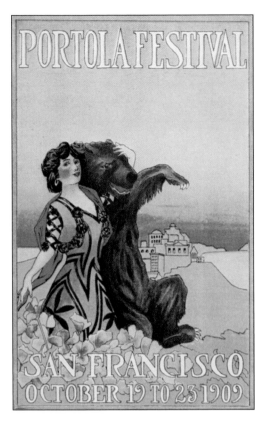

Still recovering, the city celebrated its progress to date with its first Portola Festival in October, 1909. The parades, sporting events, and parties not only showed that life had rapidly returned to normal, but that San Franciscans still knew how to frolic until the wee hours. These revels without a pause lasted five full days and nights.

One of the highlights of the Portola Festival was the arrival of Don Gaspar himself on the 240th anniversary of his first visit. Although in 1769 he had traveled by land, this time he came by sea, landing at the Ferry Building, then parading to Golden Gate Park. Almost 500,000 people attended the Portola Festival's different events, a resounding success for a city of some 535,000 residents.

24

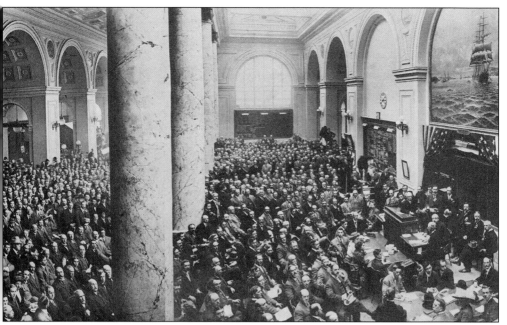

The idea of a great fair in San Francisco never disappeared entirely, but the Portola Festival certainly revived it. On December 7, 1909, a public meeting endorsed the concept. Then, on April 28, 1910, at a meeting, seen here, attended by more than 2,000 people, the exposition company sold more than $4 million worth of stock in two hours.

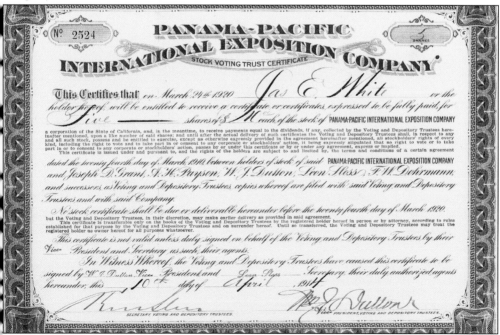

To raise money and involve the public, the Exposition Company sold stock at $10 a share to all comers. But rather than issue stock certificates, the company decided that all shares would go into a stock voting trust. The company avoided enthusiastic shareholders who might have tried to vote their views regarding the fair. Ownership rights were granted in 1920.

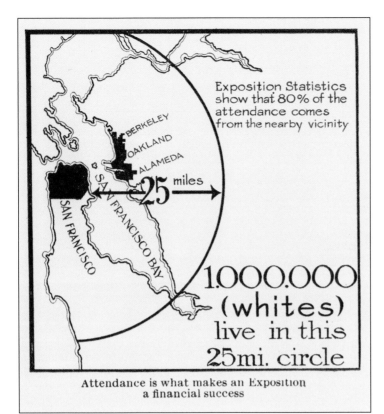

Exposition Statistics show that 80% of the attendance comes from the nearby vicinity

25 miles

1.000.000 (whites) live in this 25mi. circle

Attendance is what makes an Exposition a financial success

Many cities wanted to host a Panama Canal world's fair, so San Francisco conducted a huge public relations and lobbying campaign, most effectively with information brochures and with postcards. As many as 2 million cards a week reached Congress. The deciding factor, however, seems to have been the City's promise to accept no federal tax dollars to build the exposition, a pledge that no other city could make.

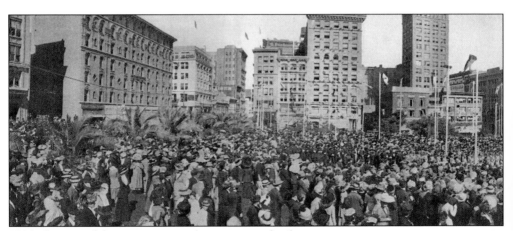

1910, the year of the most intense electioneering for the exposition, saw even more progress in the city's recovery, which it proudly showed off. On September 9, 1910, as part of a three-day celebration, tens of thousands of San Franciscans gathered in a newly reconstructed Union Square to celebrate Admission Day, an anniversary that is no longer as fervently observed.

The year 1910 culminated with a concert on Christmas Eve at Lotta's Fountain, across from a rebuilt Palace Hotel. Some 100,000 San Franciscans gathered to hear the great coloratura Luisa Tetrazzini sing for the people who loved her as much as she loved them and their city. A plaque on the fountain commemorates the occasion.

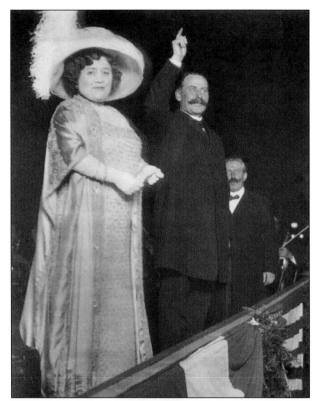

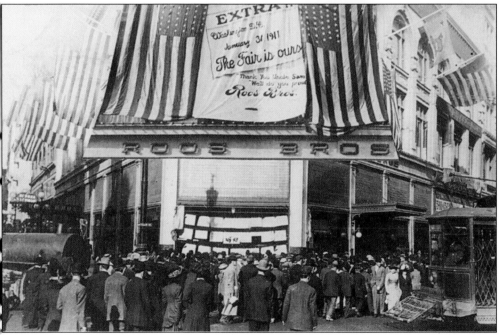

When the intense lobbying on all sides ended, congress awarded the exposition to San Francisco on January 31, 1911. As wisdom is always worthy of recognition, citizens toasted the decision late into the night. Pres. William Taft signed the legislation on February 15, 1911.

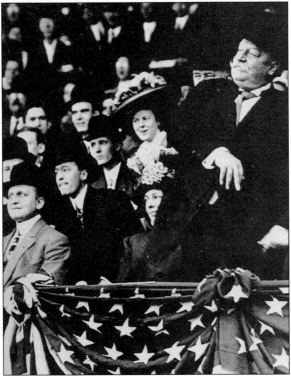

Taft was of the third generation of perhaps the most prominent political family in American history. His grandfather had been a judge, and his father served as secretary of war under Ulysses Grant. Both his son and his grandson became senators. His great-grandson Robert A. Taft II was elected governor of Ohio in 1998. In 1900, Pres. William McKinley appointed Taft chair of a commission to organize a civilian government in the Philippines, which Spain had ceded to the United States at the end of the Spanish-American War. From 1901 to 1904, Taft served as the first civilian governor of the Philippines, where the above photograph was taken. Theodore Roosevelt named him secretary of war in 1904, and he was elected president four years later. Taft inaugurated the custom of the president throwing out the first ball to start the baseball season.

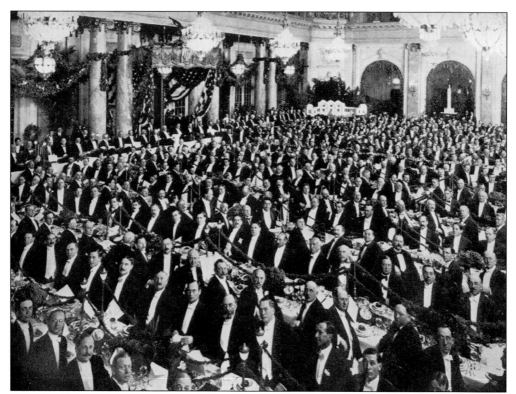

His invitation engraved on a gold plate, the president himself journeyed to San Francisco to participate in the groundbreaking ceremonies. On the evening of his arrival, October 13, he was feted at the "largest and most sumptuous banquet thus far held in San Francisco, City of Famous Feasts." Only gentlemen sat with Taft. Ladies enjoyed the evening seated in galleries about the dining room.

ADMIT ONE
P.P.I.E.
AT OUTER GATE
STADIUM, GOLDEN GATE PARK
OCTOBER 14, 1911
NOT GOOD IF DETACHED

Directions for Reaching Grand Stand—Automobiles—By main drive, Golden Gate Park to Stadium entrance. Street Car—McAllister No. 5; Clement, No. 2; Mission, No. 23, to 36th Avenue.

INVITED GUEST TICKET

The Directors of the Panama Pacific International Exposition cordially invite you to be present at the Stadium, Golden Gate Park Saturday, October Fourteenth, Nineteen Eleven to assist in the ceremony of turning the First Spadeful of Earth by

President William Howard Taft

for the

Panama Pacific International Exposition

San Francisco, Nineteen Fifteen

ADMIT TO GRAND STAND

The fair site had yet to be chosen, so groundbreaking took place in Golden Gate Park, one of the possible fair locations. The Exposition Company provided grandstand seating for 5,000 invited guests, but more than 100,000 people showed up to watch the exercises.

The ceremony began with "Yankee Diva" Lillian Nordica singing "The Year's at the Spring" and concluded with "The Star Spangled Banner," not yet the national anthem. After prayers and speeches, Taft turned a spadeful of dirt with a silver shovel, then raised the exposition's official flag. The next day at a luncheon, he called San Francisco "the city that knows how."

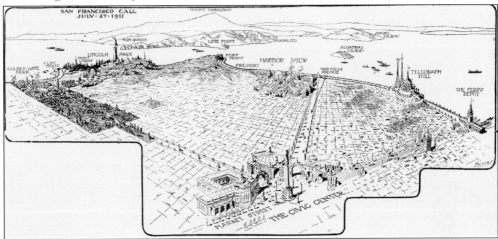

At the time of the president's visit, the favored proposal was to divide the fairgrounds among several sites, including Telegraph Hill; Harbor View and the Presidio; Lincoln Park; Golden Gate Park; and the civic center. By December 1911, however, the board of directors decided to use only the north shore sites. Just one element of the earlier concept—a civic auditorium near city hall for the fair's congresses and conventions—survived.

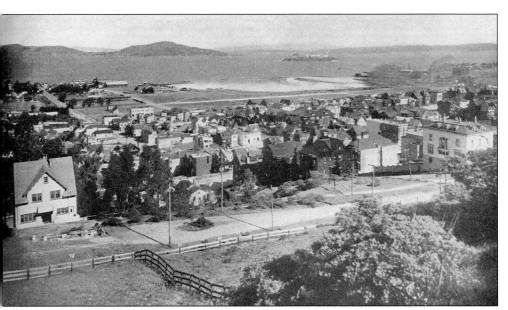

To create a single parcel for the fair at Harbor View, the exposition signed agreements with some 175 different proprietors, not all of whom owned the land or had the legal right to lease it to the company. It bought several parcels, borrowed others, then moved or razed everything on them, including homes, apartment buildings, small shops, large factories, and the city's infrastructure of streets, lights, power lines, and utilities.

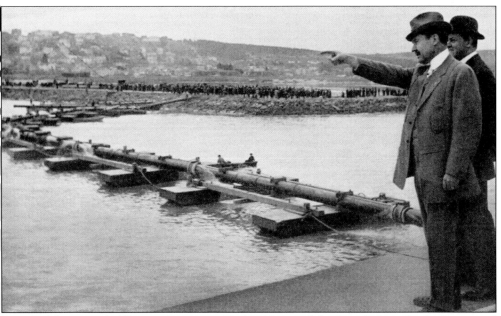

First work began with filling in the cove at Harbor View and the Presidio's wetlands. Crews used a suction dredge to pump some 1.3 million cubic yards of sludge from the bottom of the bay, maintaining a mix that was about 70 percent sand and 30 percent mud. An additional 400,000 cubic yards of muck filled in the Presidio wetlands.

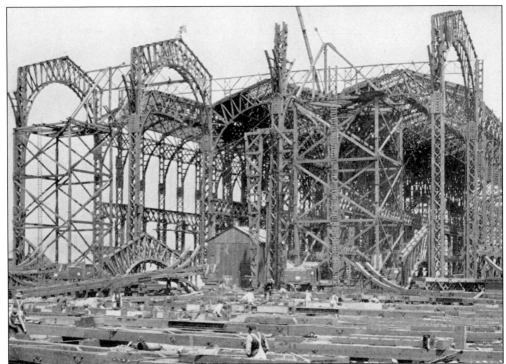

The first contract to build an exhibition hall—the Palace of Machinery—was let January 7, 1913. On New Year's Day 1914, its walls and roof in place, San Franciscan Lincoln Beachy, the world's most famous aviator, piloted his biplane through the vast interior, the first indoor flight. Such insouciant daring won him admirers all over the world. The building was completed on March 10, 1914, 11 months before the fair opened.

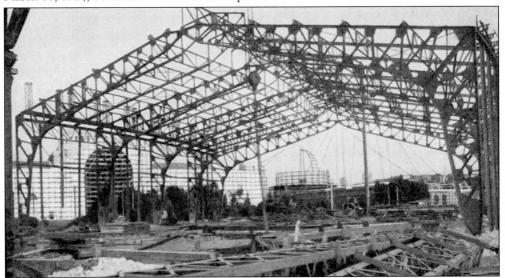

The site chosen for the Palace of Fine Arts at the western end of the great exhibition halls was previously the site of Rudolph Herman's Harbor View Resort. Designed to be temporary structures, most of the large buildings used wood framing, but the Palace of Fine Arts was framed in steel, a necessary fireproofing precaution for the valuable collection it would display.

Many feared that San Francisco's strongly organized labor force would plague the enterprise with excessive demands and strikes for higher wages, slowing down or stopping altogether the construction of the fair. San Francisco mayor P.H. McCarthy suggested that the unions and the exposition's management sign a letter of understanding, outlining wages and working conditions acceptable to both sides. Claiming it lacked the authority to negotiate, the exposition declined to participate, but labor leaders pledged to cooperate anyway, if the exposition's contractors gave preference to hiring union members. Although the exposition never agreed formally and not all workers hired belonged to unions, the labor organizations honored the understanding for the duration of the fair. Above, the framing for the Tower of Jewels goes up. Below, the Palace of Education and its dome take shape.

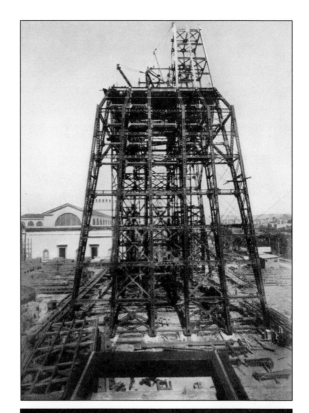

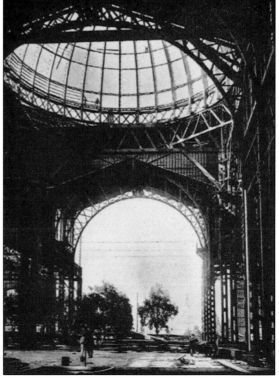

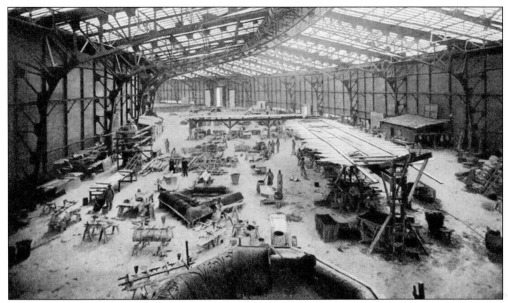

Still under construction, the Palace of Fine Arts' exhibit hall became an enormous atelier, turning the approved models of the exposition's many statues and groupings into life-sized and larger-than-life works of art.

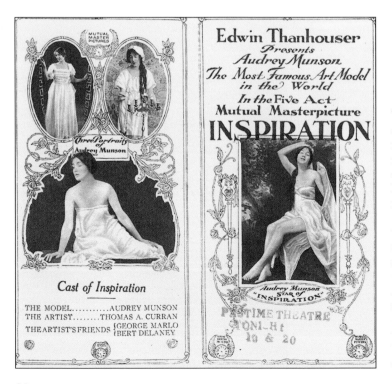

The model for most of the fair's sculpted female figures—and many of its painted ones—was Audrey Munson, the most famous art model in the world at the time. The year the exposition opened, she achieved screen immortality in *Inspiration* as the first actress in a film made in the United States to undress tastefully, but completely, on screen.

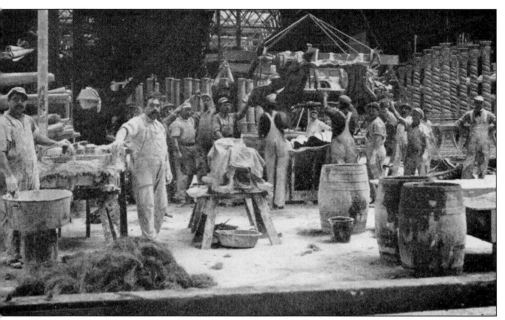

To fulfill their commissions, many of the exposition's sculptors set up studios on the fairgrounds, where most of the sculpture was produced. A few works, created elsewhere, were made to be permanent, but most were to be as temporary as the buildings and courtyards they complimented.

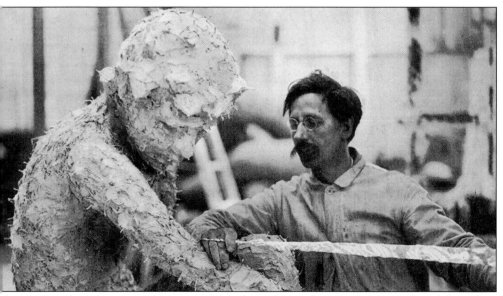

Artisans used a pointing machine to enlarge the sculpture from their approved models to their heroic final dimensions. Frameworks were wood and wire, with the rest made of imitation travertine—the same material used on the outer walls of the exhibit halls.

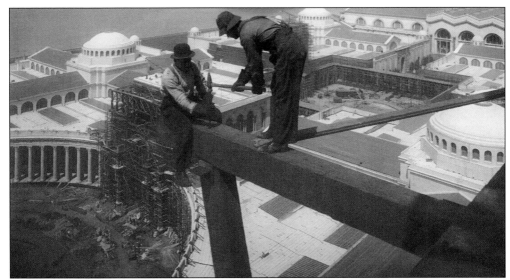

Working high above the Court of the Universe, workers had a spectacular view of the fair's progress. A mostly complete Machinery Hall is to their right; the Arch of the Rising Sun takes shape just to their left. Located between the Tower of Jewels and the Marina Green, the court became the heart of the exposition.

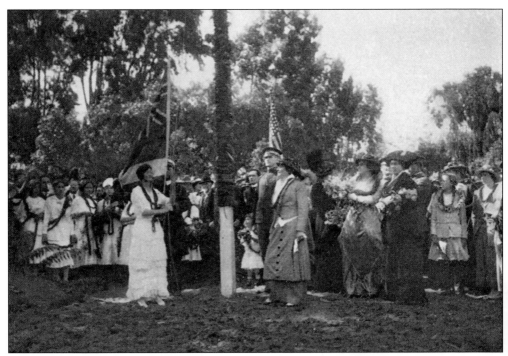

Every possible occasion was used for ceremony, celebration, and publicity. Groundbreaking for Hawaii's Pavilion included speeches, sod turning, and a flag raising. Visitors to the PPIE heard the ukulele played there for the first time in the United States; within a few years, the instrument—the name means "jumping flea" in the Hawaiian language—was a national craze.

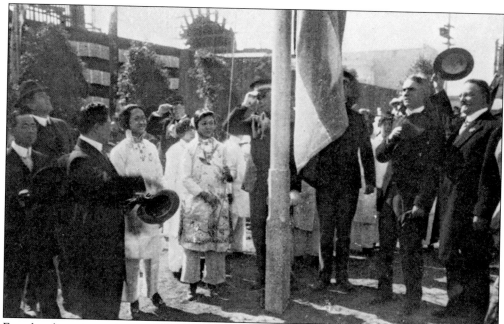

For the first time, the new Republic of China, founded in 1911, had a pavilion at an international exposition. Groundbreaking wasn't controversial, but many Chinese Americans objected to the old-fashioned clothing the workers brought from China and to their living conditions—a dormitory built of crude planking and without floors, with workers' beds propped up on the beach sand.

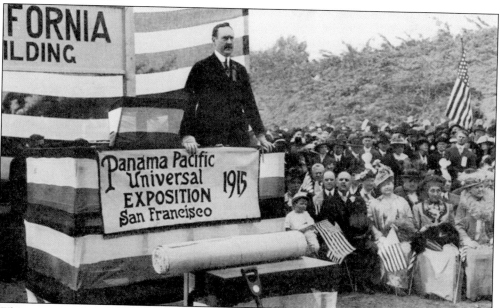

When exposition president Charles Moore spoke at the California Building's groundbreaking, the fair's official name had not been finalized. After a few brief comments, he revealed an artist's rendition of the pavilion (the scroll pictured on the table). In the front row, left to right, are San Francisco mayor James Rolfe; Mrs. Rolfe; and Phoebe Apperson Hearst, honorary president of the exposition's Women's Board.

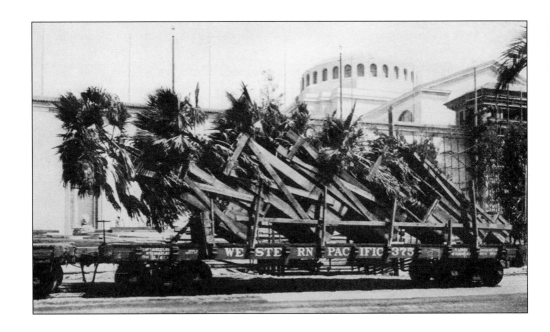

With almost no plants of any kind on the fairgrounds' 635 acres of drifting sand dunes and landfill, landscapers began by covering the sites designated for trees and gardens with a thick layer of surface soil. Short on time for new planting and growing, they simply transplanted specimens from a collection begun in 1912. Given that the exposition opened in the winter and closed more than nine months later, evergreens were selected exclusively as the shrubs and trees. The main exhibit halls were built to be uniformly 60 feet tall, so the cypress, palms, and eucalyptus near them had to be 30 to 50 feet tall. Most of the trees arrived by freight train and were moved into place by derrick.

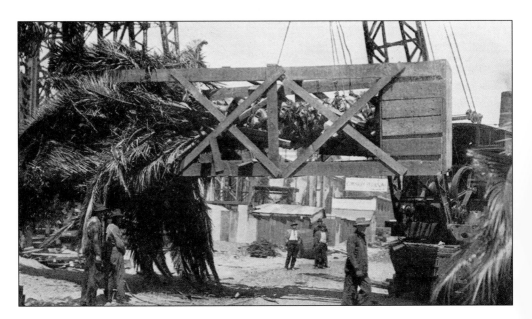

One of the fair's largest and most unusual landscaping projects was the security wall along Chestnut Street. Instead of the typical board fence, it was a barrier made up of *Mesembryanthemum specablilis*, or South African dew plant. Cuttings were planted in boxes—8,700 of them—two feet wide, six feet long, and two inches deep, held in place by wire netting until the growth obscured it.

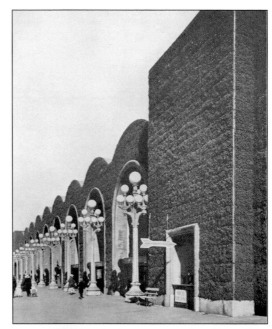

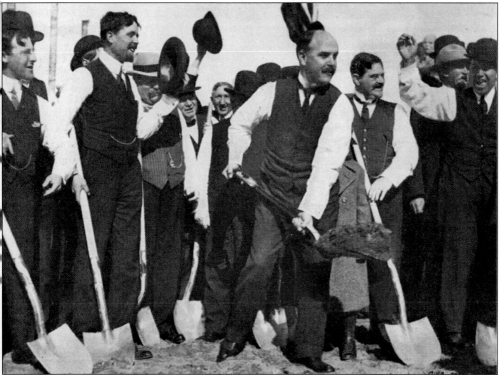

While it was being built, the fair was not San Francisco's only large construction project. On April 5, 1913, Mayor James Rolfe (center) broke ground for a new city hall. The building's designers were Bakewell and Brown, who also designed the exposition's Palace of Horticulture. Construction continued throughout the exposition period, and the building was dedicated on December 28, 1915, three weeks after the fair closed.

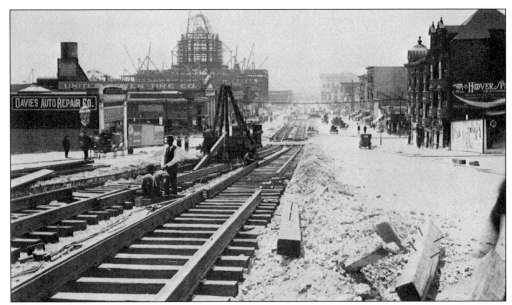

Because of the limited streetcar service to Harbor View and the fairgrounds, the new Municipal Railway, the first publicly owned in the United States, built rails to the fairgrounds on Van Ness Avenue. Construction began on April 6, 1914. This photograph looks toward Market Street a month later; the skeletal structure of the new city hall is clearly visible in the background. All work was completed by August 14, and the line opened for business the next day.

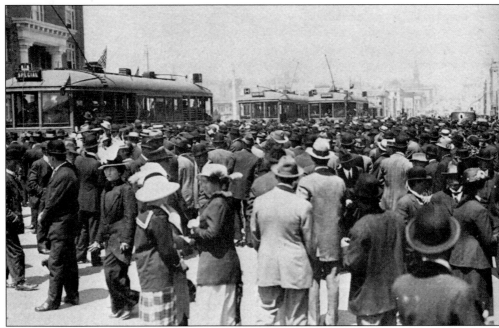

On August 15, 1914, the opening of the H line was celebrated with speeches and a parade of rolling stock. United Railways (then privately held) designated its streetcar routes with numbers, so the Muni chose to identify its lines with letters. The City has owned all rail service since the 1940s, but the previous differentiation still survives.

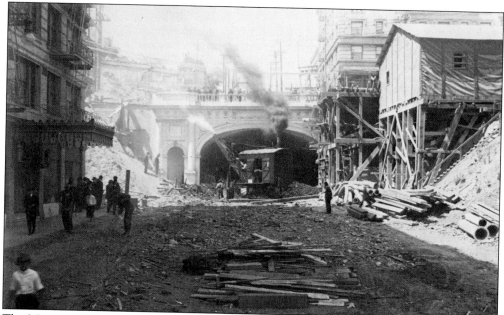

The Municipal Railway also moved forward to provide a direct transit line to the exposition from downtown, Chinatown, and North Beach. Work on the Stockton Street Tunnel, the key to the route, began in April 1913. By the time of this July 1914 photograph of the south portal, workers had almost finished removing the rock core. The tunnel opened on December 28, 1914, the widest clear span in San Francisco.

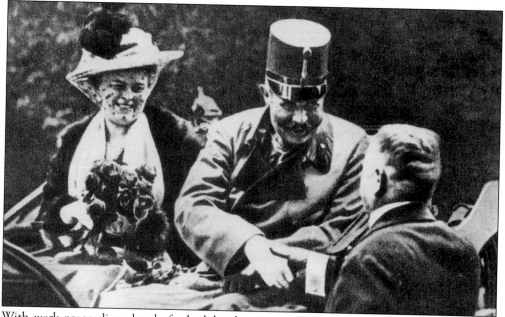

With work proceeding ahead of schedule, the exposition suddenly faced one final, daunting challenge: the Great War in Europe. The assassination of Austrian archduke Franz Ferdinand and his wife, Sophie (pictured just before they were shot) was the catalyst. The fair seemed about to lose many of its most important exhibitors and many foreign visitors, who now would be unwilling or unable to travel to San Francisco.

Open on time
War will not affect the 1915 Panama Expositions

Plan now to go and visit <u>Grand Canyon</u> of <u>Arizona</u> on the way ——

Four trains a day, including California Limited
The Santa Fe de-luxe (extra fare) weekly in winter

On request will send you our Panama Expositions and California trains folders.
W. J. BLACK, Passenger Traffic Manager
Atchison Topeka & Santa Fe Railway, 1064 Railway Exchange Chicago

Two fairs for one fare
Santa Fe **California** 1915
Panama Exposition

Because of the war in Europe, many people wanted to postpone or cancel the exposition, even though construction was more than 90 percent complete when the conflict started. Given the energy and expense to create it—and the ephemeral nature of its buildings and business arrangements—the management refused. Regardless of any notion of the Santa Fe Railroad, there were no gondolas or inland waterways at the San Francisco exposition.

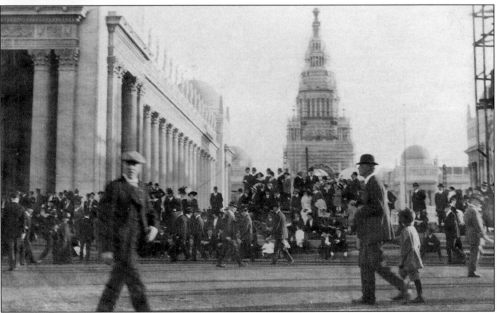

This photograph shows a typical day at the exposition—before the opening. The Tower of Jewels and other buildings are still enveloped by scaffolding. Throughout the period of construction, San Franciscans visited the grounds to inspect the progress of their fair. At first admission was free, but so many people came out to supervise that the management began charging 25¢ for adults, 10¢ for children.

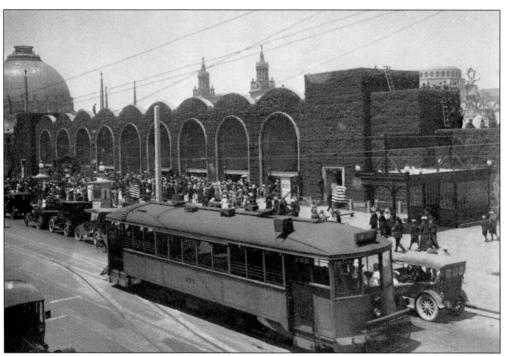

By opening day, when this photograph was taken, the Municipal Railway had completed two new lines to the fairgrounds and had plans to run special service on other, existing routes. Public ownership of public transportation was still considered a radical idea, but the Muni proved so successful in completing its work in record time that it received "congratulations and commendations" in a special resolution of the board of supervisors.

Although most visitors used the city's public transportation system, they also arrived in their own or hired carriages and automobiles. Many out-of-towners went out to the exposition as one stop on a guided tour that might include visits to Mission Dolores and the Presidio. No one dared to be seen in public without an appropriate hat. The fare for adults was $1.50, which included admission to the fairgrounds.

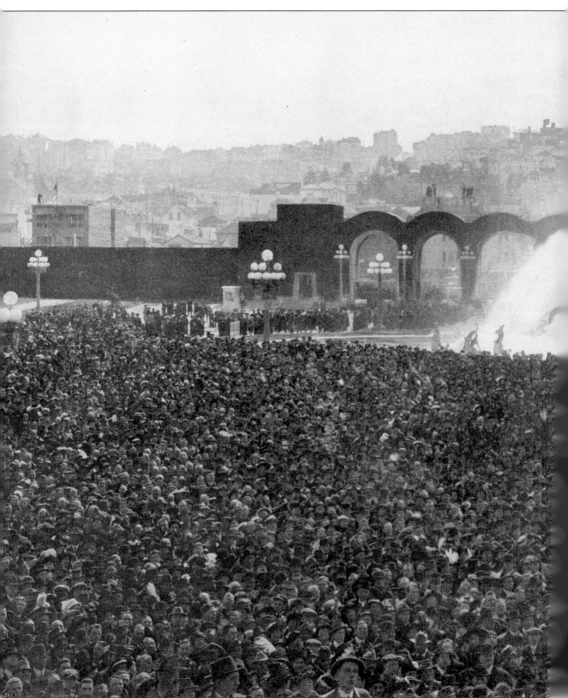

On opening day, February 20, 1915, Mayor Rolph led a parade of 150,00 residents and visitors up Van Ness Avenue to the fairgrounds. By the time they reached their destination, the marching bands and other parade components had been completely lost in the crowd. It was only because so many had purchased their admissions weeks before that the pay gates were not overwhelmed. Speeches were kept especially brief. At precisely noon, President Wilson pressed

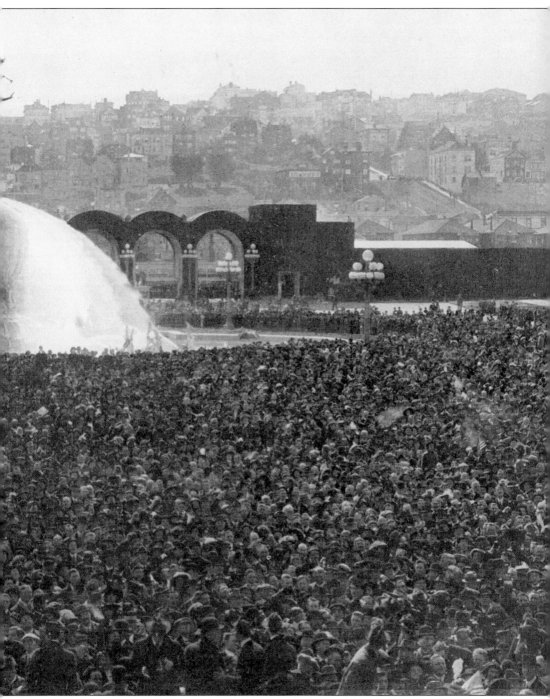

a gold telegraph key in Washington to send a signal to an antenna on the Tower of Jewels. The great doors to the exhibition palaces swung open. Cannons boomed. Crowds cheered. The city's grandest celebration had begun. By the end of the day, more than 250,000 people passed through the turnstiles, equivalent to half the population of San Francisco.

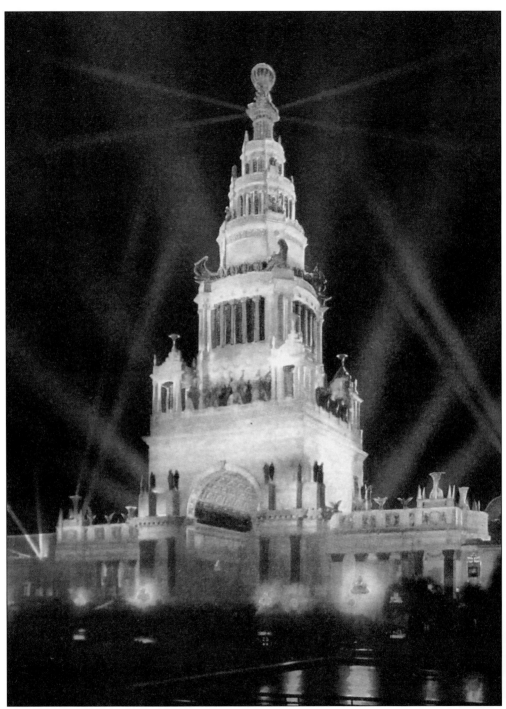

At 435 feet, the Tower of Jewels was tallest structure on the fairgrounds. It had been designed to be the signature building of the exposition, but ceded that honor to the Palace of Fine Arts before opening day. Covered with 102,000 Austrian cut-glass "novagems," each backed with its own mirror and hung on its own wire, their movement in the breeze gave the Tower a magical feeling, especially at night.

Three

PALACES OF PROGRESS

The PPIE opened to the world on February 20, 1915, on time and on budget, a first for an American world's fair. Because of the war in Europe, not every item for every exhibit had arrived, but all the great exhibit halls had been finished early; the other facilities were in place; the infrastructure was done; and everything worked.

The Louisiana Purchase Exposition, the previous grand world's fair held in the United States, had so many buildings spread across so many acres that people complained of its vastness. The builders of the PPIE decided to minimize the distance by using a block plan that made all the main exhibit halls part of one enormous complex.

Although the fairgrounds spread across 635 acres on a tract two and a half miles long and one-half mile wide, the block plan enabled the exposition to group all its great exhibit halls within a relatively small amount of space, saving visitors both their shoes and their strength. The greatest distance between two halls was eight blocks, a vast improvement over earlier plans. The amusement zone was a separate area to the east, virtually isolated from the more serious endeavors. State buildings, foreign pavilions, livestock exhibits, and sports facilities were to the west.

Although the architecture of the great halls looked to a romantic past, the exhibits embraced change and looked toward a progressive future. For the first time ever at any exposition, fairgoers could take an airplane ride. They could visit an automobile assembly plant in operation; displays of buggies had vanished completely. They could see a million-volt electric transformer; talk on a transcontinental telephone connection; ride on a trackless streetcar; and see hundreds of other innovations great and small that promised a better world.

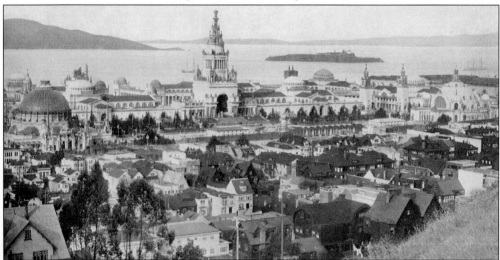

From afar, the exposition very much looked the romantic, idealized destination it had been designed to seem, an "idyllic city upon a fill," as one wag put it. Dominated by the Tower of Jewels, no American exposition had a more exquisite location. Pictured on the far right is the domed Palace of Horticulture; Festival Hall faces it across the South Gardens. Alcatraz Island is in the distance on the right.

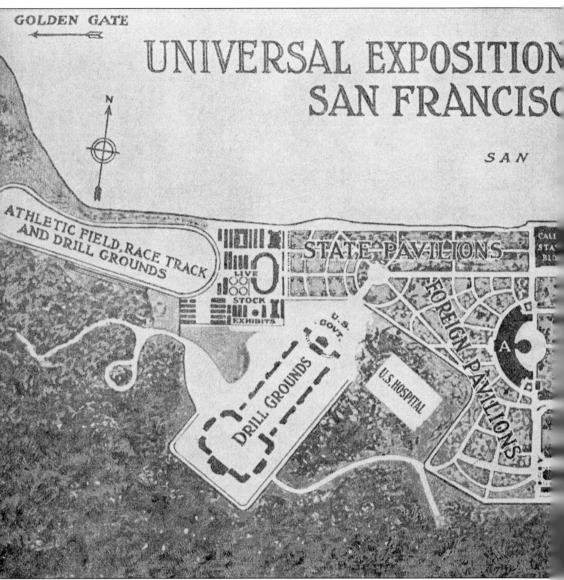

UNIVERSAL EXPOSITION
SAN FRANCISC

SAN

ATHLETIC FIELD, RACE TRACK AND DRILL GROUNDS

STATE PAVILIONS

LIVE STOCK EXHIBITS

CALI STA BLD

FOREIGN PAVILIONS

U.S. GOVT.

DRILL GROUNDS

U.S. HOSPITAL

The fairgrounds were divided into four major sections. The Joy Zone, built on 70 acres borrowed from Fort Mason, hosted the exposition's thrill rides, adventures, and carnival attractions. Grouped together in the next area were the great showplaces, a 220-acre display of the world. Still walking west, visitors came first to the foreign pavilions and state buildings, then the facilities for livestock and athletic competitions; entirely on Presidio grounds, they

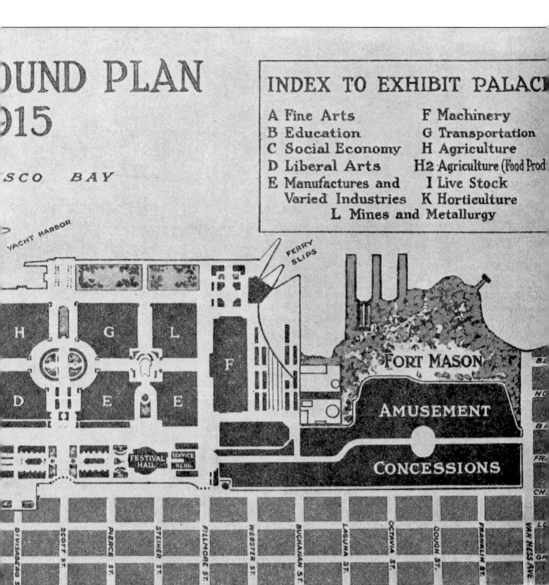

UND PLAN
915

SCO BAY

YACHT HARBOR

FERRY SLIPS

FORT MASON

AMUSEMENT

CONCESSIONS

FESTIVAL HALL SERVICE BLDG

DIVISADERO ST. SCOTT ST. PIERCE ST. STEINER ST. FILLMORE ST. WEBSTER ST. BUCHANAN ST. LAGUNA ST. OCTAVIA ST. GOUGH ST. FRANKLIN ST. VAN NESS AVE.

covered 110 acres. No one could hope to see it all. The 11 great exhibit halls alone had more than 70,000 exhibits. Visiting each as little as three minutes would have required more than a year of 10-hour days; adding the state, foreign, and livestock exhibits would have required even more time.

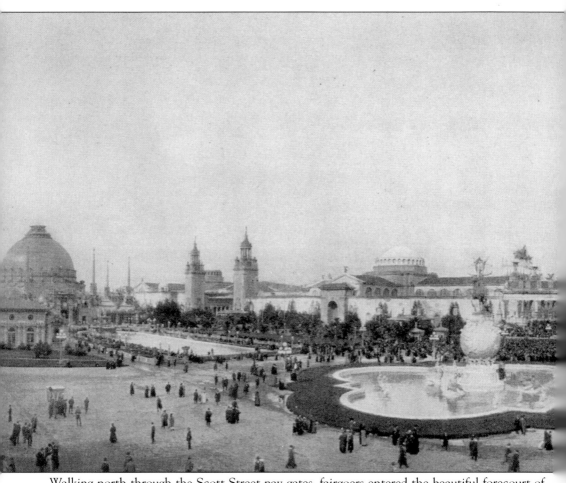

Walking north through the Scott Street pay gates, fairgoers entered the beautiful forecourt of the exposition, the great South Gardens. This massive public space 1,200 feet wide and 1,700 feet long stretched between Festival Hall to the east and the Palace of Horticulture to the west. Directly ahead was the Tower of Jewels, flanked by the Palace of Liberal Arts (left) and the Palace of Manufactures and Varied Industries (right). At the center of the plaza itself was the enormous Fountain of Energy, sculpted by A. Sterling Calder, who also served as the fair's

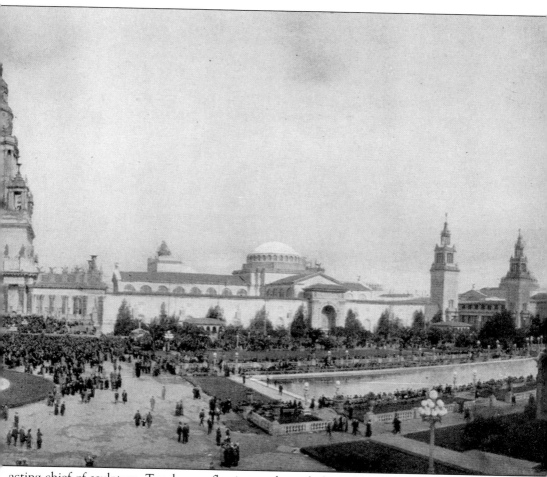

acting chief of sculpture. Two large reflecting pools, each framed by flowers and bordered by lawns, flanked it on two sides. John McLaren, chief of landscape gardening (and longtime superintendent of Golden Gate Park), and his son Donald, assistant chief of landscaping, chose the flowers specifically to compliment the fair's color scheme. Given that two years earlier the parcel had been sand dunes, their achievement not only dazzled visitors, it amazed them.

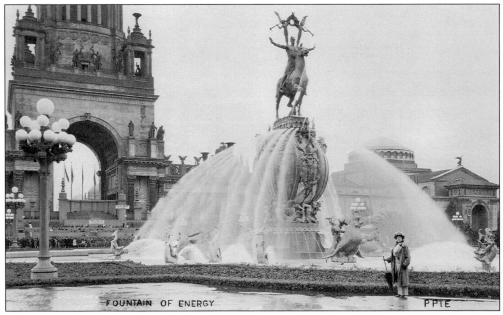

A. Sterling Calder's Fountain of Energy was at the center of the South Gardens. The artist believed it was "the sculpture that interprets the meaning of the exposition," and that without it "you would have no visible symbols to characterize or interpret its purpose and its accomplishment." The Fountain incorporated symbols that told the story of the Panama Canal and expressed the essential spirit of the exposition.

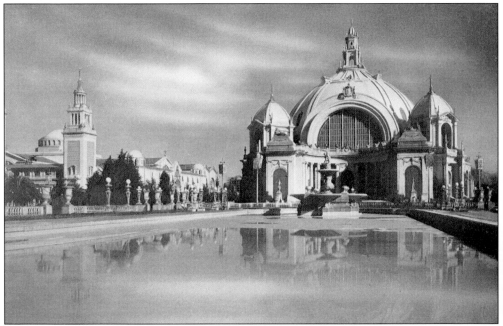

Festival Hall, on the South Garden's east end, was the focal point of the exposition's grand music festival of more than 2,000 concerts, many of which were held outdoors, free of charge. Its architecture inspired by the Theatre des Beaux Arts in Paris, the vast concert hall seated 4,000 people; a recital room upstairs was used for more intimate performances.

The Boston Symphony played 12 concerts in Festival Hall between May 14 and 25. Every seat sold out, so a 13th performance was added for May 26. All-Wagner, all-Italian, all-Russian, and two all-French programs were featured. In 1918, Darmstadt-born conductor Karl Muck was denounced as a resident alien, interned until the Great War ended, and deported.

During their era of great popularity, many of the world's notable musicians and bands visited the exposition: John Philip Sousa; the great Giuseppe Creatore (pictured here); Patrick Conway; Philip Pelz's Russian Band; and Thaviu's Band. The host Exposition Band was conducted by Charles Cassasa, who also led the Midwinter Fair's band 21 years earlier. Most band concerts were given outside in one of the exposition's courtyards. Prof. Harold Hill would have been ecstatic.

FESTIVAL HALL
PANAMA-PACIFIC INTERNATIONAL
EXPOSITION GROUNDS

May 14th to 25th
EVENT OF THE SEASON

TWELVE CONCERTS
BY THE

Boston
Symphony Orchestra

Dr. Karl Muck, Conductor

C. A. ELLIS, Manager

THE WORLD'S GREATEST ORCHESTRA
OF 100 ARTISTS

Eight Evenings **Four Matinees**

SEATS ON SALE AT
343 POWELL STREET
(St. Francis Hotel Bldg.)

W. H. LEAHY, Local Manager

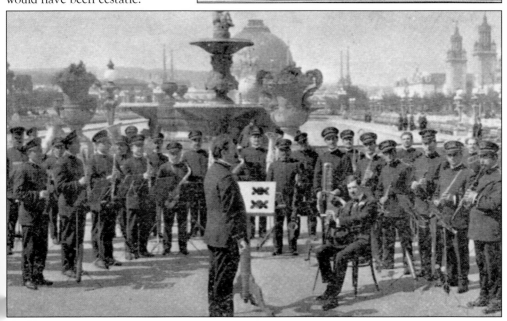

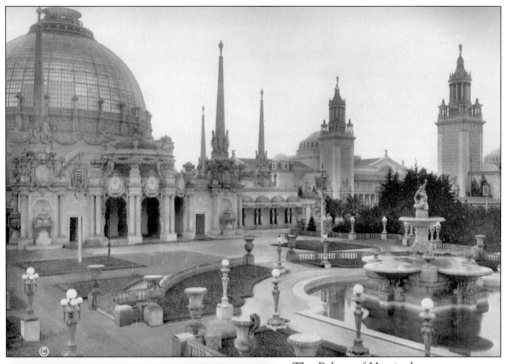

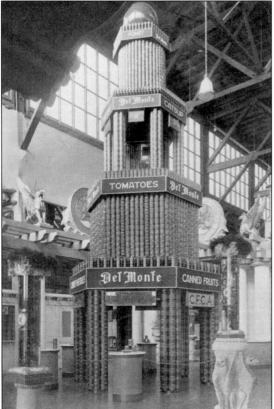

The Palace of Horticulture was perhaps the most eclectic of all the great exhibit halls. Architects Bakewell and Brown modeled the building after the great mosque of Ahmed I in Constantinople, but with ornamentation of the French renaissance and decorative trellis similar to that of Louis XIV.

Under the massive dome of the Palace of Horticulture—182 feet high and 152 feet in diameter—fairgoers found an elaborate display of fruits, plants, and the equipment to grow them. Del Monte's exhibit, with its tower of revolving cans, won the only grand prize for canned fruits at the exposition. Every day the fair was open, some 1,000 visitors enjoyed the company's offer of free samples of fruits and vegetables.

The Main Tower, or Tower of Jewels, was meant to be the signature structure of the exposition. Planned to rise more than 500 feet, it was redesigned to reach only 435 feet , which saved the fair $100,000 in construction costs. Many critics found it disproportional and overly ornamented, but admitted that the Great Arch was impressive. The public adored it.

The Tower's most beautiful and memorable feature was its use of 102,000 Austrian cut-glass jewels, made by the Novagem Company. Each backed by a reflecting mirror and attached to the building with its own wire, the gems added a shimmering effect to the tower during a breeze and gave it an aeriform one at night. Few saw the top of the tower this close up.

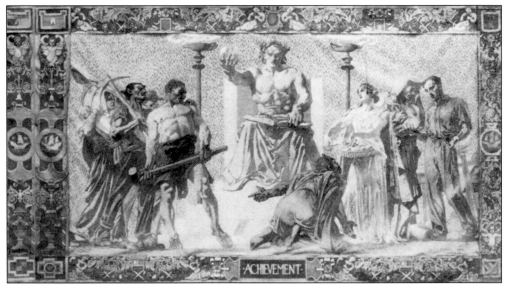

Walking under the arch of the Tower of Jewels (110 feet high, 60 feet wide) fairgoers viewed six murals by William de Leftwich Dodge that allegorically presented the history of the Panama Canal. On the east wall was *Gateway of All Nations*, flanked by *Labor Crowned* and *Achievement*, shown here. On the west wall was *Atlantic and Pacific*, flanked by *Discovery* and *Purchase*.

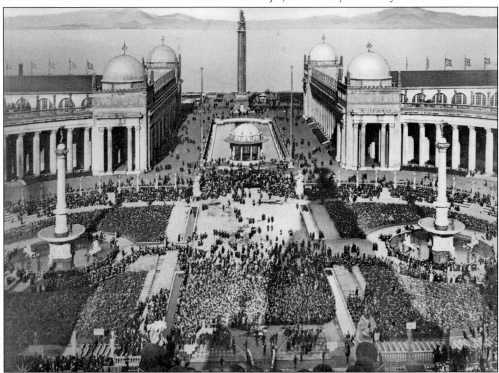

Leaving the Tower of Jewel's archway, visitors entered the Court of the Universe, the true center of the exposition. It was inspired by Vatican City's Piazza of Saint Peter, although at seven acres it was much bigger. Sterling Calder's *Star Maidens* peered down on the multitudes, who came here for many of the fair's numerous public ceremonies, concerts, and other events.

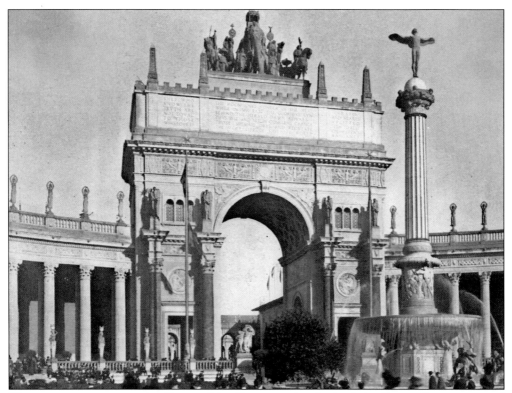

The eastern entrance to the Court of the Universe, the Arch of the Rising Sun represented the contributions of the "Oriental peoples" to civilization. Crowned by the enormous sculpture group *Nations of the East*, it was as tall as a 15-story building. Atop the column directly in front of it, Adolph Weinmann's *Ascending Day* prepares to take wing.

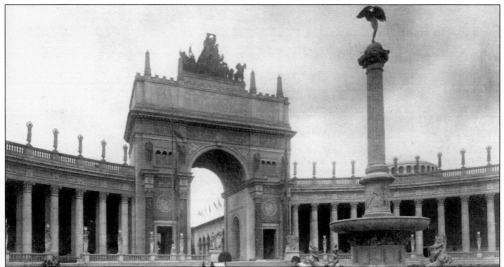

Directly across the expanse of the Court of the Universe, the Arch of the Setting Sun symbolized the "Western nations." Its heroic sculpture *Nations of the West* depicted the different peoples of the Americas, all under the protective wings of a guardian angel. *Descending Night*, also by Weinmann, prepares to fold her wings on the top of the nearby column.

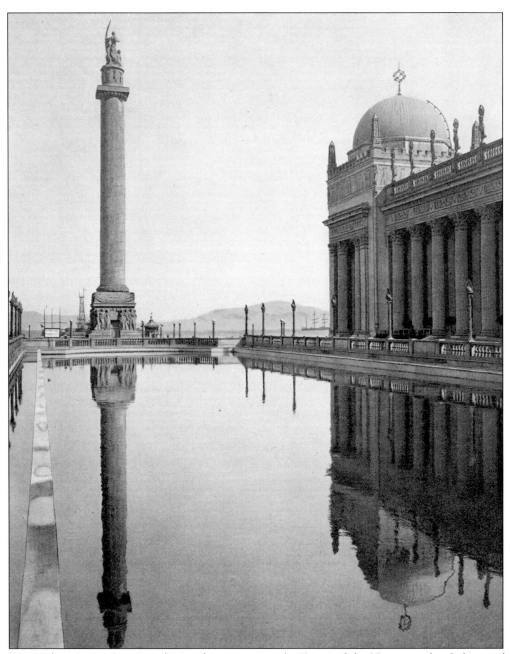

Set on the Marina Green at the north entrance to the Court of the Universe, the Column of Progress celebrated human achievement. It was the first in the world not inspired by a specific, historic event—and the first sculptured column done for any exposition. Its crowning sculpture group, *The Adventurous Bowman*, consisted of three figures: the striving adventurer, pushing human accomplishment forward by shear force, poised to meet and overcome yet another challenge; the steadying companion, supporting his arm and his success; and the devoted woman, ready to crown him with laurel. Some cynics wondered how the archer could achieve anything without a string in his bow, but sculptor Hermon MacNeil said he omitted it for aesthetic reasons only.

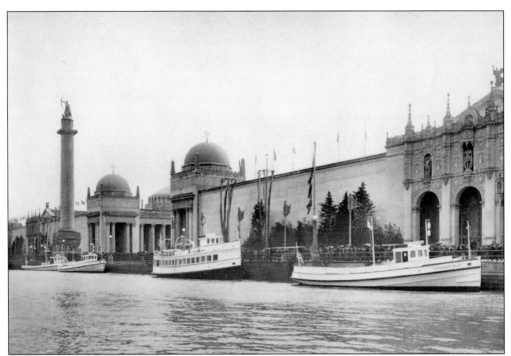

Seen from the water, the Column of Progress marked the north entrance to the Court of the Universe. Visitors from the Bay Area could sail their own vessel or take one of these ferry boats—which stayed in service on the bay after the exposition closed—directly to the fairgrounds. Many of the fair's water carnivals took place here. The Palace of Transportation is on the left; the Palace of Agriculture is on the right.

Operated by men from the United States Marine Camp within the fairgrounds, the searchlights that formed the Scintillator, on the outer arm of the yacht harbor, played an important role in lighting the nighttime exposition. The huge apparatus used colored screens and moving beams to create an inspiring psychedelic light show. Some feared that the display was visible from space and might attract unwelcome visitors, but none made themselves known.

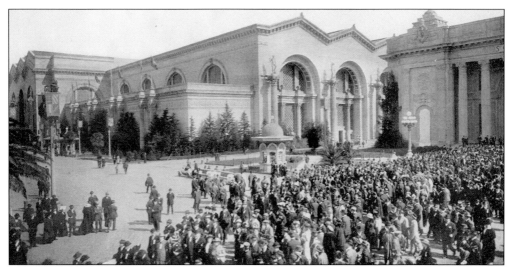

The Palace of Machinery, the largest building on the fairgrounds, was the first exhibit hall to be completed, and so became the first to be used, months before opening day. It was inspired by the Baths of Caracalla in Rome, which also inspired the beautiful Pennsylvania Station in New York.

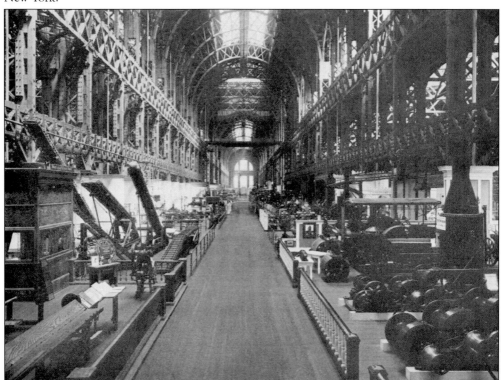

The central aisle of the Palace of Machinery showed the vastness of the exhibit hall. Displayed here were all the wonders of modern American heavy machinery: machine tools, steam, gas, and oil engines; freight and passenger elevators; printing presses; storage batteries; and safes. The United States government had extensive displays here of battleships, submarines, and military equipment, including torpedoes and sunken mines.

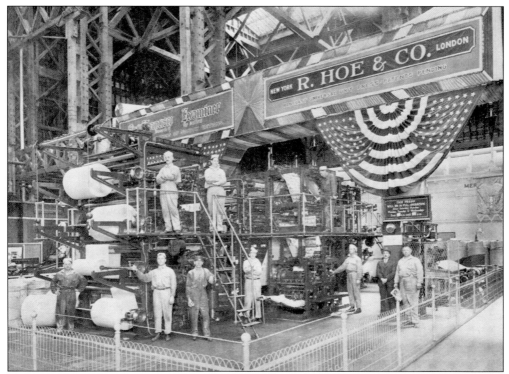

On display in the Palace of Machinery, the great Hoe press, owned by the *San Francisco Examiner*, was the largest color press in the world. In daily operation at the fair, it printed the color sections of the newspaper's Sunday editions. Built in New York, it traveled through the Panama Canal to reach the exposition. The exhibit received a grand prize.

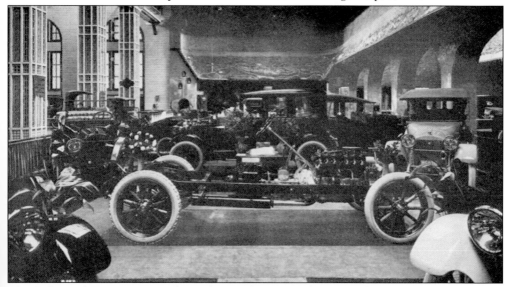

The Palace of Transportation housed something new for a grand American exposition: a display of automobiles. At the St. Louis World's Fair in 1904, the extensive exhibit of personal transportation consisted entirely of horse-drawn vehicles, not one of which was shown at the PPIE. Clearly, the "gasoline horse" was here to stay.

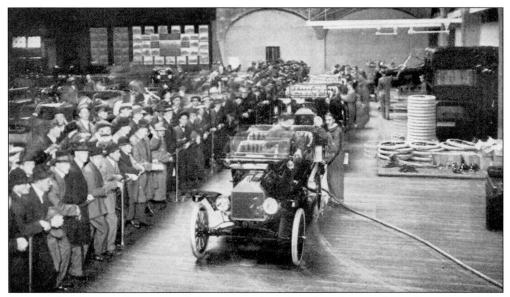

So completely was the automobile captivating the American public that one of the most popular exhibits at the exposition was the Ford assembly plant in the Palace of Transportation, a first at any world's fair. In operation only three hours each day, except Sunday, it produced a new car every 10 minutes. The entire run of 4,338 vehicles sold out months before the fair closed.

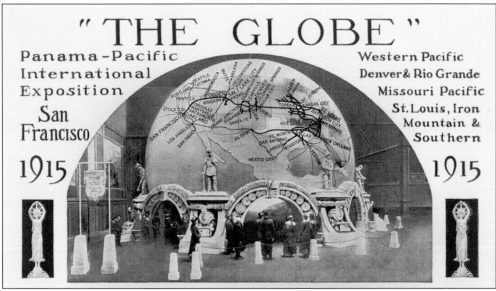

The railroads were whole-hearted supporters of the exposition—they expected to sell millions of excursions to the fair—and many took the opportunity to present themselves to the public. The Globe housed dioramas of scenes along the route of the Western Pacific and two other railroads. The train trip from San Francisco to St. Louis took three minutes.

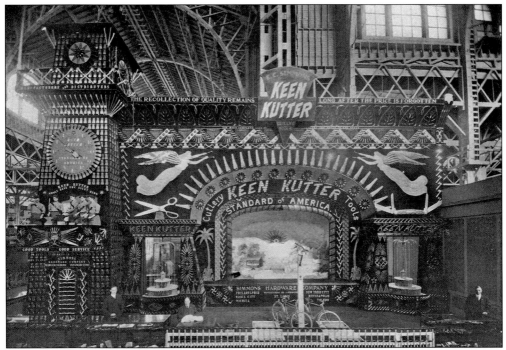

To attract the public's attention among thousands of competing displays, exhibitors did whatever they could. At the Keen Kutter exhibit in the Palace of Manufactures, that meant setting everything into motion. Pocketknives constantly opened and shut; windmills of blades spun continually. Most everything else at least twirled, circled, or revolved. The company's representatives had no fears that visitors would fingerprint the merchandise.

The Palace of Education was home to several schools, the first at any exposition. Maria Montessori herself traveled to the exposition to establish a classroom to demonstrate her principles of childhood learning. There also was a Standard Commercial school; a Palmer school of penmanship (pictured here); and schools for blind and deaf students.

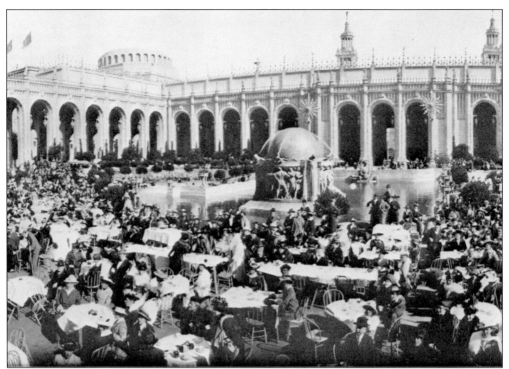

What could be more appropriate than a luncheon in the Court of Abundance? At its center, Robert Aitken's Fountain of the Earth symbolically portrayed the dawn, the fullness, and the end of life on earth. Many people believed the gardens and courtyards of the exposition were its most beautiful features.

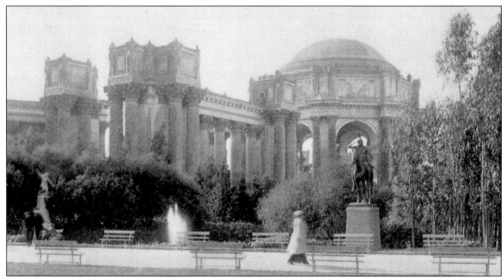

At the western end of the great exhibition halls, the beloved Palace of Fine Arts, not the Tower of Jewels, became the fair's signature building. Following the color plan of the exposition, the walls were ivory travertine, the columns were ochre or green, and the dome was orange. The exposition filled the lagoon with swans that were soon joined by ducks, whose adjoining wetlands had been filled to create the fairgrounds.

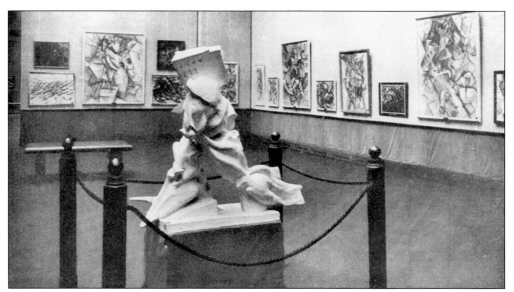

The paintings exhibited in the Palace of Fine Arts spanned the time from Tiepolo to the present, although easily one-third of them were American, most of these created within the last 10 years. For the first time at a world's fair, much of the sculpture was displayed outside the building.

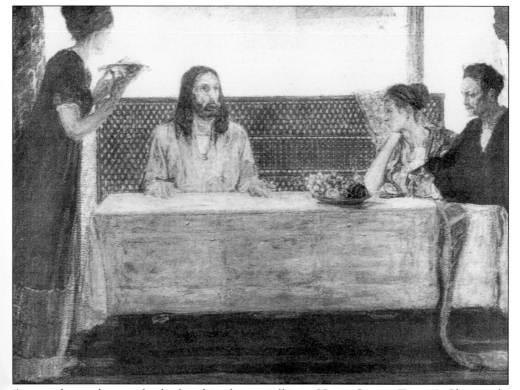

Among the modern works displayed in the art galleries, Henry Ossawa Tanner's *Christ at the Home of Lazarus* won a gold medal. He was first African American artist to receive international recognition and to be elected a full member of the National Academy of Design.

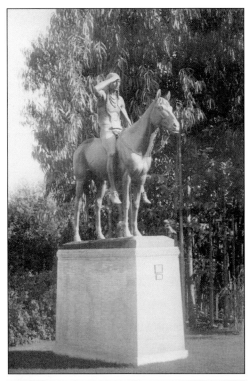

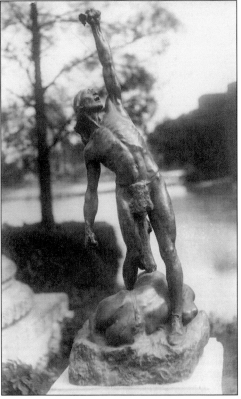

Native Americans were depicted everywhere at the exposition, although they had no say in how they were presented. The images ranged from the noble savage of Cyrus Dallin's *The Scout* to the bloodthirsty renegade of *The Scalp* by Edward Berge. Although both views had been present in the American mind from the earliest days, by 1915 they essentially were irrelevant. The year of the fair, there were fewer than 250,000 Native Americans living in the United States, the lowest number in history, and except for a nostalgia for pioneer days, they had become virtually invisible to the public.

The most moving image of a Native American, and the fair's most popular sculpture, was James Earle Fraser's *End of the Trail*. Wrote Juliet James, "His trail is now lost and on the edge of the continent he finds himself almost annihilated." Unauthorized copies began appearing almost immediately, and it was one of the very few sculptures made of artificial travertine to survive the demolition of the fair.

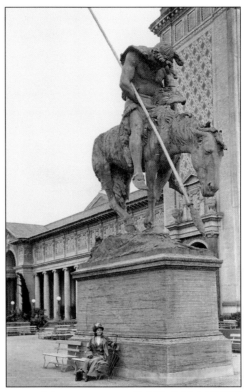

Paired with Fraser's statue was Solon Borglum's *The Pioneer*. According to Juliet James, "To him should be given the glory for the great achievements that have been made on the American Continent. He endured the hardships, carved the way across the continent, and made it possible for us of today to advance thru his lead." The sculptor's son was instrumental in creating the Mount Rushmore National Memorial.

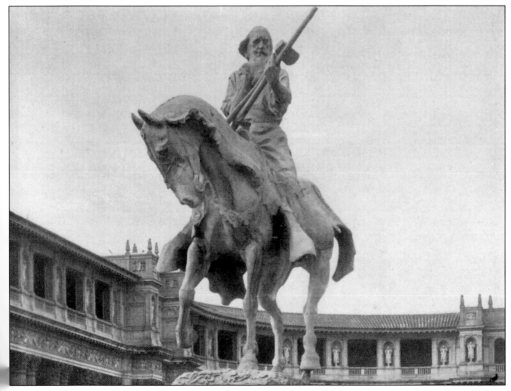

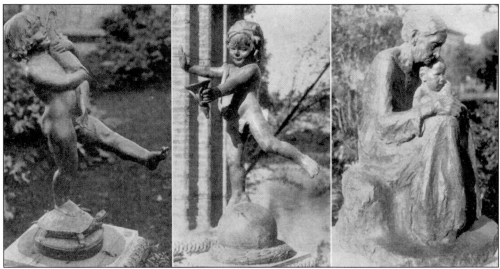

Other sculpture was of a more sentimental nature. *Boy with Fish* by Bella L. Pratt, Janette Scudder's *Flying Cupid*, and *Mother of the Dead* by C.S. Pietro were representative of the other works displayed about the Palace of Fine Arts.

In all ways, the exposition was its own community, complete with a hotel, the Inside Inn. Singles without bath were $2, $2.50, and $3; or with a bath, they were $3 to $5. Suites began at $10. Rooms at the Fairmont began at $4, but, unique to San Francisco, every one had its own bath.

Instead of recruiting from any existing police force, the Exposition Guard hired only honorably discharged United States soldiers, sailors, and marines, a first for any American world's fair. They policed the grounds and guarded the exhibits, helping those who had become perhaps "too festive" to leave the grounds.

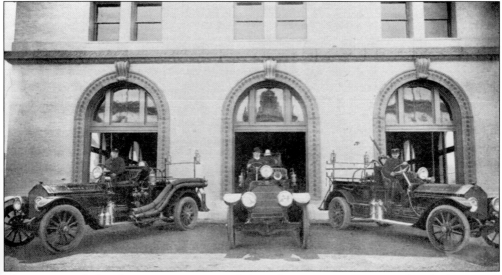

The exposition's fire department maintained three fire stations, all equipped with the newest motor vehicles. At the time, it was the only fire department in the Bay Area to have no horse-drawn equipment.

The Fageol auto trains were something new for an American world's fair: trackless streetcars. It cost only 10¢ to ride; more than 3 million visitors at one time or another chose to save their shoe leather and their strength, making the concession a great success. Here, two of the trains pass by the Palace of Varied Industries.

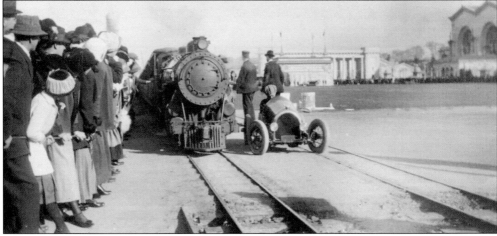

The Overfair Railway ran on 2.5 miles of track along the northern boundary of the fairgrounds. Even at a competitive 10¢ a trip, it did not make a profit. Here, aviation daredevil Art Smith prepares to challenge the train in his midget racer, the *Comet*. Four locomotives were saved when the exposition closed. The California State Railway Museum, Sacramento, has one on display, and three operate on the Sawnton Pacific Railroad, south of San Francisco.

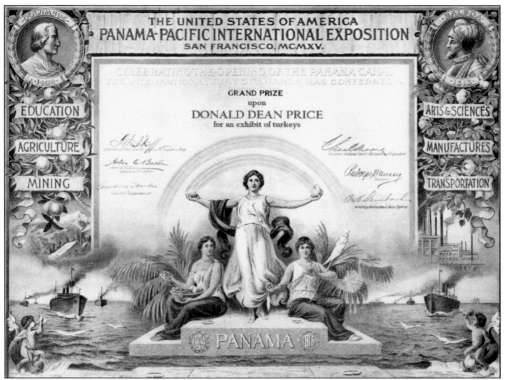

The United States Bureau of Engraving and Printing produced the exposition's certificate of award, designed by Clair Aubrey Huston, who created most of the United States stamps between 1903 and 1919. Marcus Baldwin, one of the country's top banknote engravers, did the engraving. Recipients were also presented with a ribbon and a medal of award.

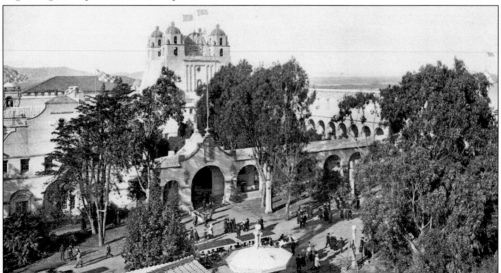

North of the Palace of Fine Arts, the California Building was the largest state pavilion ever built at an American world's fair. It housed exhibits from all the state's counties. After the PPIE closed, some wanted the building to become the state's normal school in San Francisco, but this was not to be.

Because of its immense reception and ballrooms, the exposition company used the California Building for its many social occasions. Most state and foreign pavilions had their own facilities, but none was as large, so others used it too.

OREGON BUILDING

AT THE

P.
P.
I.
E.

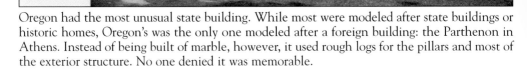

Oregon had the most unusual state building. While most were modeled after state buildings or historic homes, Oregon's was the only one modeled after a foreign building: the Parthenon in Athens. Instead of being built of marble, however, it used rough logs for the pillars and most of the exterior structure. No one denied it was memorable.

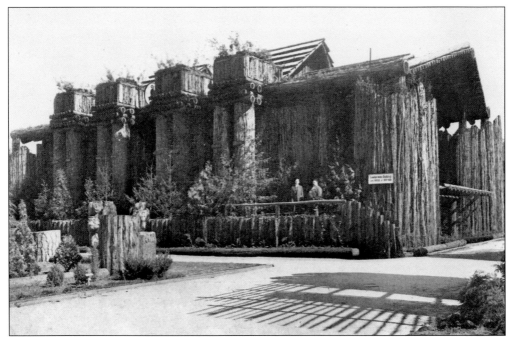

American lumbermen commissioned Bernard Maybeck to design their exposition headquarters. His House of the Hoo-Hoos was built from a variety of native and coast wood log and bark strips. For this one of two buildings he created for the fair, Maybeck whimsically repeated the same double columns, topped with the same garden boxes, which he used for the Palace of Fine Arts.

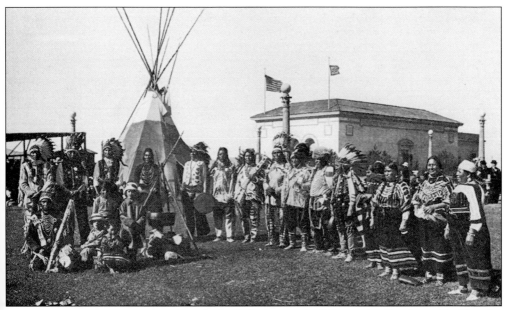

Several corporations, mainly railroads, had their own buildings: the Southern Pacific; the Grand Trunk System; the Canadian Pacific; and the Great Northern, which settled Glacier Park Indians on its site as an added attraction.

73

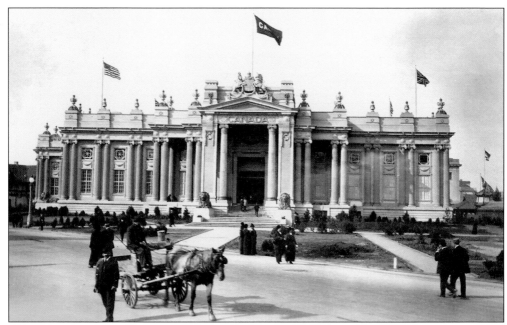

Canada was the only North American country to have a pavilion at the exposition. To be awarded the fair, San Francisco stated that it would not take any government funds, so the United States did not provide for any for its own separate facility. Its exhibits were spread throughout all the exhibit's palaces. After United States marines invaded Tampico and Vera Cruz in 1914, Mexico declined the honor of having its own building.

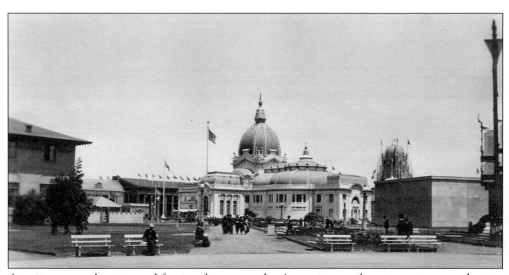

A rarity among the state and foreign showcases, the Argentine pavilion was not a reproduction of any already existing building. Serving more as a consulate than an exhibit hall, it housed a reception room, a small theater for lectures and moving pictures, a writing room, and a library.

An exposition celebrating the completion of the Panama Canal would have been incomplete without a pavilion representing the country through which it passed. Although a showplace was duly constructed, it never opened to the public, as the new government of Panama decided that a world's fair of its own would be more suitable.

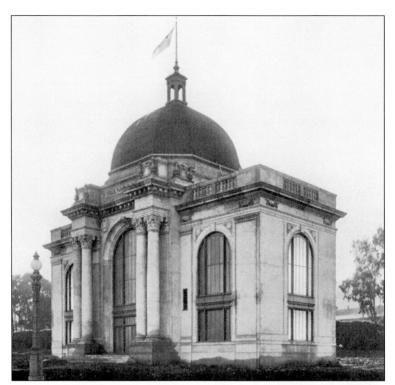

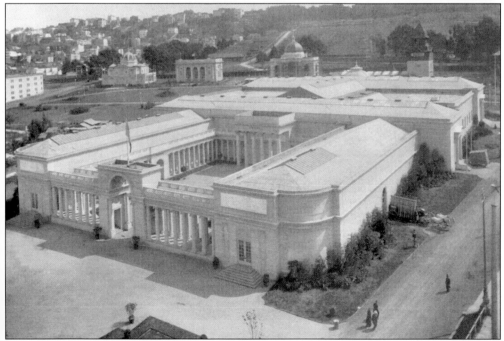

Because of the war, both Great Britain and Germany declined to have pavilions at the PPIE, but France persevered and built its facility in record time. San Franciscans were so impressed that they recreated the French Pavilion as a museum in Lincoln Park, a copy of a copy of the Palace of the Legion of Honor in Paris. The building also housed an exhibit from Belgium.

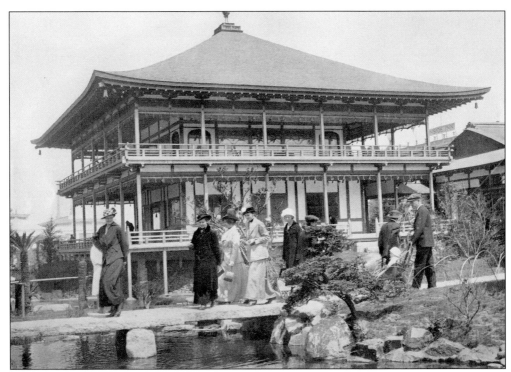

Fronting the Avenue of Nations, the Japanese Pavilion occupied one of the largest sites in the foreign section, its grouping of buildings and their surroundings covering nearly four acres. The Reception Hall, seen here, was the tallest structure in the compound, a reproduction of the Kinkakuji Temple at Kyoto. Everything used at the location was brought from Japan, including rock, gravel, turf, and several thousand plants.

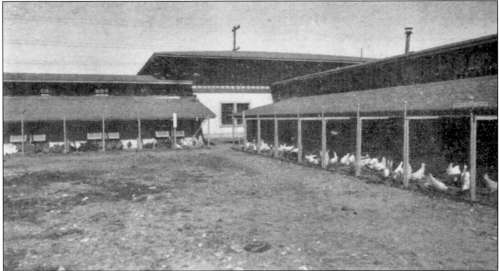

Located west of the state and foreign pavilions, the livestock exhibits were among the most popular at the exposition. They included a model dairy cattle barn, which demonstrated milking machines; a model horse stable; and a poultry building, shown here, whose hens were engaged in the International Egg Laying Contest.

The exposition's official poster showed the building of the Panama Canal as the 13th labor of Hercules. Had the stables of King Augeas looked like their counterpart at the fair, complete with potted palms, he could have avoided his fifth labor. The PPIE's horse show was followed by shows for cattle, sheep, goats, swine, and poultry, among others.

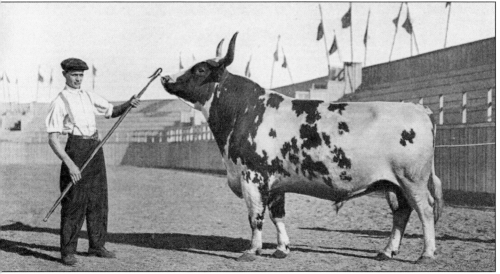

One of the popular participants in the cattle show was My Beuchan Peter Pan, the grand champion Ayrshire bull who traveled to the exposition from his home in Redmond, Washington. The fair was the first to have continuous livestock exhibits throughout the entire period it was open.

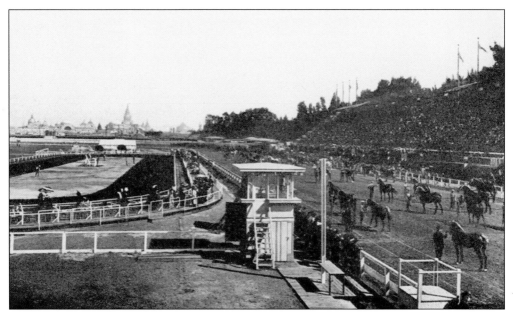

West of the livestock exhibits, on what would become Crissy Field, the track became the focal point for the fair's many sporting events, including automobile and horse racing (seen here), polo matches, an international military tournament, and displays of livestock for best of breed.

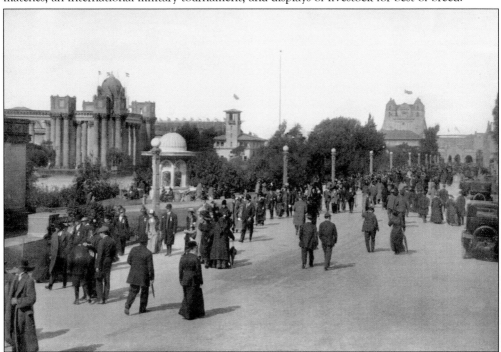

Many fairgoers enjoyed promenading on the exposition's broad walkways. Here, strolling north on Administration Avenue, visitors pass the Palace of Fine Arts (on the left) and head toward the California Building (in the distance). Men wore suits to every public occasion. Women wore clothing with high necklines, long sleeves, and ankle-length skirts. No one left home without a hat.

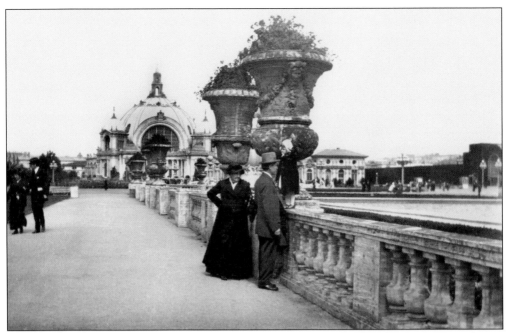

Looking south across the great South Gardens, two visitors stand at a balustrade decorated with immense urns made at the fair of artificial travertine, like most everything else on the grounds. Festival Hall looms behind them. The east end of McLaren's growing wall is visible across the reflecting pool.

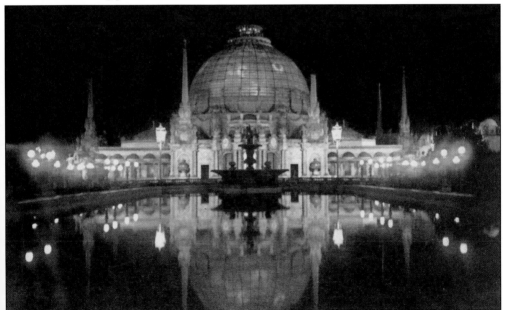

Many boosters and most critics believed that the fairgrounds were most beautiful after sunset, especially in the fog—boosters because the fair's nighttime lighting added an ethereal quality to the experience, and critics because the darkness and the fog hid architecture they did not like. Here, the Palace of Horticulture seems to cast a glow from within that glistens in the reflecting pool.

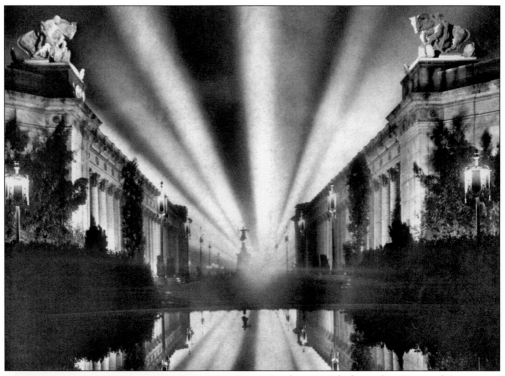

Looking north from the Court of Four Seasons toward the Scintillator, the night sky is alive with light, color, and motion. The Scintillator, which created the aura behind the buildings, was a battery of searchlights located on the breakwater in the Yacht Harbor. It projected different colors using tinted filters.

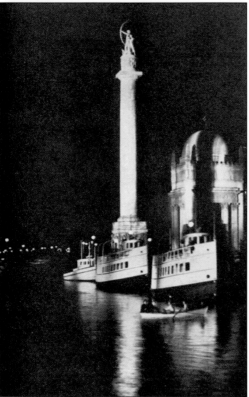

The Yacht Harbor at night, the exhibit palaces, and the soaring Column of Progress conveyed feelings of harmony and peace to many visitors. Given the deep-seated belief in progress and its potential to solve future problems, all seemed right with the world.

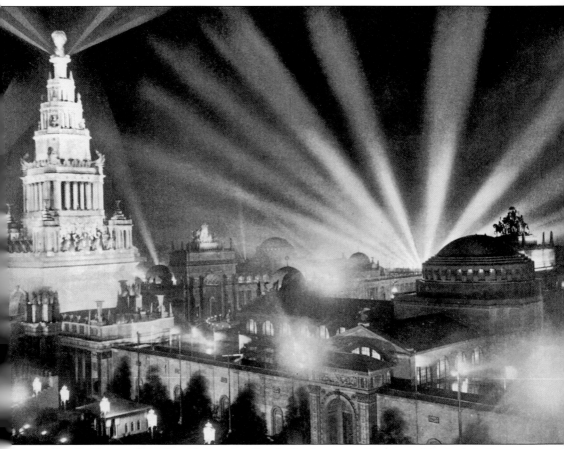

At night, the Tower of Jewels and the great South Gardens were illuminated by both indirect lighting and the Scintillator. Fog diffused the searchlights on some evenings, adding to the romance and imagination.

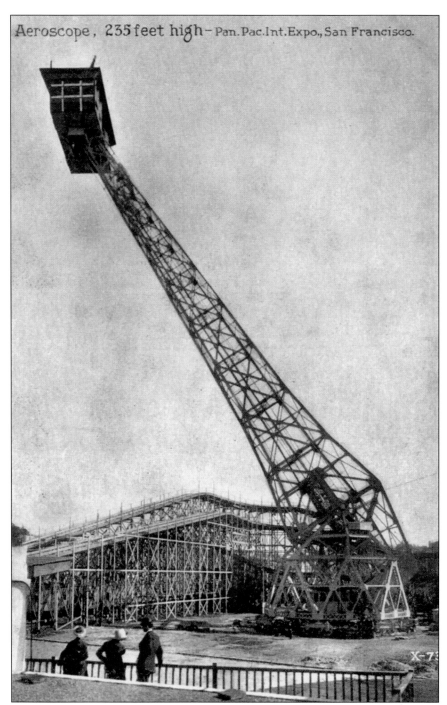

Aeroscope, 235 feet high – Pan. Pac. Int. Expo., San Francisco.

The Aeroscope was the exposition's answer to the Ferris wheel. With a two-story observation booth at the end of a 200-foot-long steel arm, it lifted passengers high above the fairgrounds for a panoramic view of the fairgrounds, the city, and the distant shore. The round-trip took about 10 minutes. It was built and operated by Joseph Strauss, whose masterwork, the Golden Gate Bridge, opened 22 years later.

Four

MEET ME AT THE ZONE

Since the Chicago World's Fair of 1893, amusement parks had been a part of all international expositions held in the United States. The PPIE named it the Joy Zone, a street seven blocks long, 100 feet wide that stretched from the Van Ness Avenue entrance to the Avenue of Progress, now part of Fillmore Street. Here, visitors found almost 60 attractions, restaurants, and souvenir stands that appealed to every taste and pocketbook, from the 101 Ranch, to Stella, to Japan Beautiful. Audiences were educated, amused, titillated, and thrilled.

Not every attraction on the Zone succeeded. Some blamed inclement winter and spring weather, the wettest in living memory. Others cited the high price of admission in the midst of a bad economy—50¢ for certain attractions, the same as admission to the fair. Many thought the sheer size of the enterprise and number of similar concessions caused too many attractions to chase too few coins. There were seldom enough people to create the necessary carnival atmosphere.

Many old standbys failed. Dioramas of famous battles and other catastrophes did poorly. Wild West shows closed early. Animal farms saw few customers. Thrill rides attracted business, but not all had enough to make a profit. Excessive overhead certainly contributed to the problems.

The "native villages," fixtures of previous expositions, were among the least successful PPIE attractions. The Samoan Village closed in September, victim of meager business and an impending travel date. Somali Land, the only representation of Africa at the fair, attracted even fewer patrons, so the exposition invited the company to leave. When they were slow to do so, a phalanx of exposition guards forcibly evicted them. Taken by immigration officers to Angel Island, the Somalis were eventually deported.

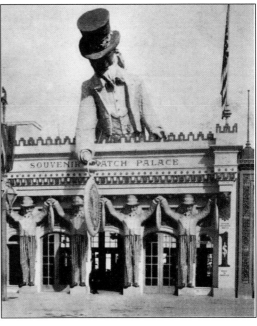

Holding an enlarged sample of the wares inside, this four-story-tall Uncle Sam added more than a little patriotism—and patronage—to the Souvenir Watch Palace, as did the caryatids. "The watch that made the dollar famous" did an enormous business during the fair. Those that have been well cared for still keep excellent time all these years after the exposition closed.

83

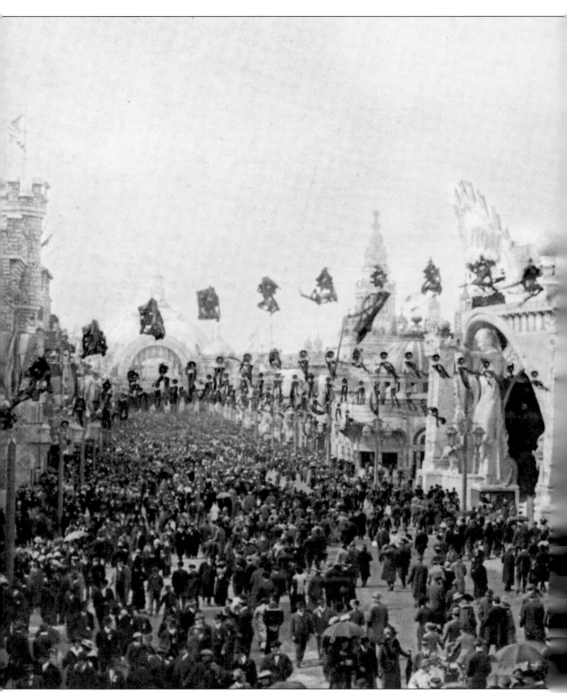

Fairgoers entering the Zone through the Van Ness Avenue gates had this spectacular view, looking toward Festival Hall in the distance. On their right were the Dayton Flood, Creation, the Panama Canal, and the Bowls of Joy. The Battle of Gettysburg, Alt Nuremburg,

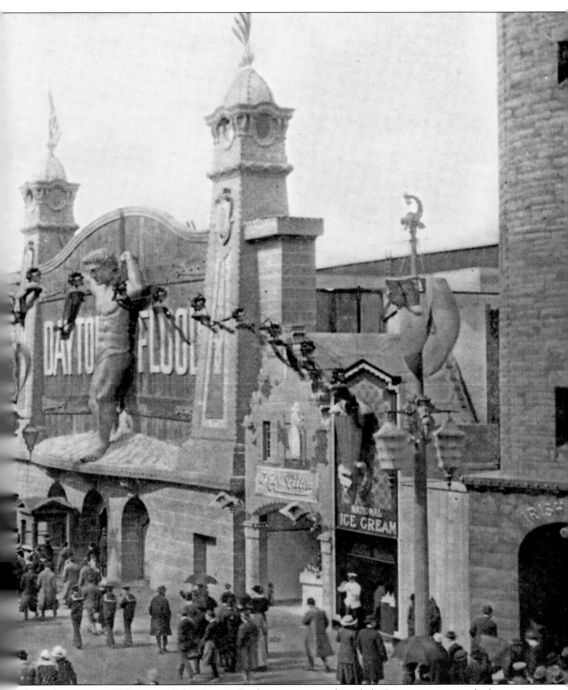

the Tehuantepec Village, and the Scenic Railway were on their left. Restaurants, snack shops, and souvenir stands were interspersed among the many attractions.

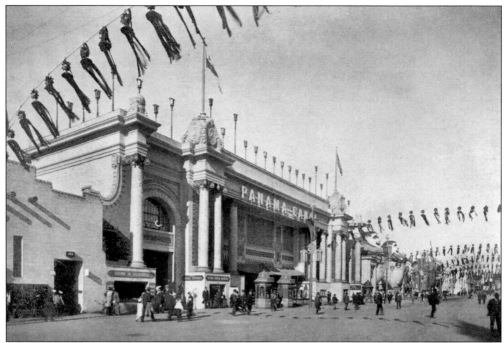

Most patrons and pundits considered the Panama Canal to be the most noteworthy exhibit on the Zone. For only 50¢, fairgoers enjoyed a guided tour of the world's newest engineering wonder, "a complete, correct, and faithful reproduction" in miniature.

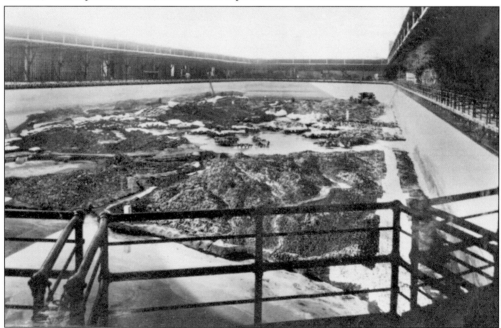

Construction crews took seven months to build the working model of the canal and another five months to make and place the artificial vegetation. When finished, the exhibit covered almost five acres. Promoters originally envisioned patrons traveling through the model in boats, but eventually abandoned the concept.

A moving platform, the longest in the world—1,440 feet long and with a seating capacity for 1,200 people—took fairgoers on a 23-minute journey around the canal. Each seat had a telephone receiver, through which visitors heard a phonograph recording that described what they were seeing.

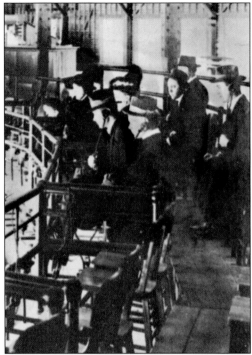

The miniature Milaflores and Pedro Miguel locks, like everything in the model, actually worked. Ships traveled back and forth, controlled by magnets.

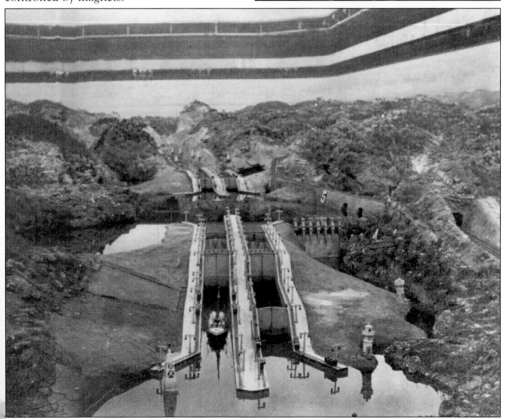

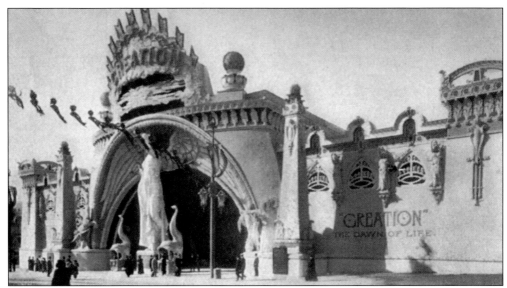

The enormous dioramas of Creation illustrated the first few chapters of Genesis "in magnificent scenic sequences" and vivid detail. The attraction did only so-so business at first, but after lowering its admission fee from 50¢ to 25¢, managed to turn a profit. The bare-breasted angel, her enormous wings forming the entry arch, had performed the same duty at the St. Louis World's Fair of 1904.

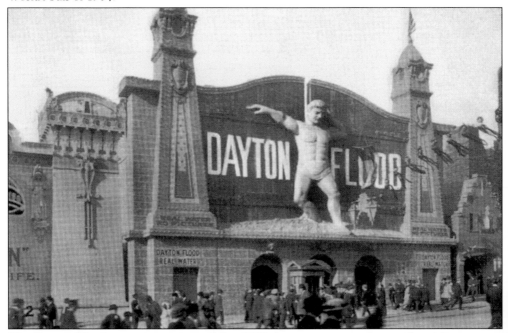

The Dayton Flood attraction recreated the 1913 devastation, complete with swirling waters, burning buildings, and distraught livestock. A popular attraction at previous world's fairs—as the Johnstown Flood at the Buffalo Exposition and the Galveston Flood at the St. Louis World's Fair—it closed after a few months of poor patronage. San Franciscans, having recently endured the worst natural disaster in American history, apparently were not interested in the entertainment value of additional destruction.

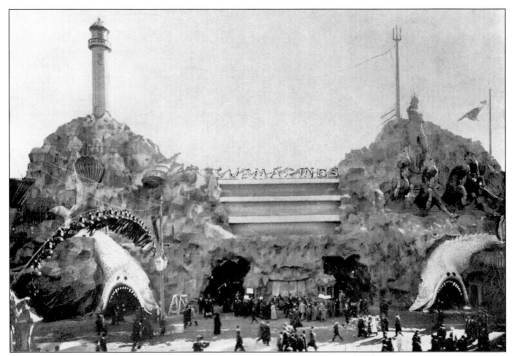

In some ways ahead of its time, the Submarine Ride was one the largest attractions on the Zone—and one of the most expensive to build. Fairgoers entered through one of the shark mouths, then wandered through coral caves or voyaged under the waters of the seven seas aboard a facsimile of a U.S. Navy submersible. Among other sites, they visited Neptune's workshop, tropical sponge beds, sunken galleons, the blue grottos of Capri, mermaids and mermen, and Davy Jones's Locker. But it wasn't all smooth sailing: a violent storm battered the submarine before returning it safely home.

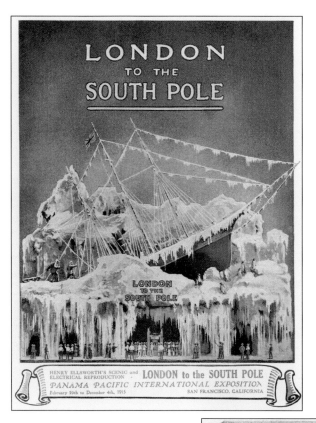

London to the South Pole presented a "scenic and electrical reproduction" of Capt. Robert Scott's tragic Antarctic expedition, from its departure from London on June 1, 1910, to its untimely end shortly after reaching the South Pole on January 18, 1912. Like many of the other Zone attractions that depicted recent disasters, it failed to attract an audience and closed early.

One reason given for the modest success of most Zone attractions was an overly generous distribution of free passes. The exposition company was rigorous in its use of complimentary tickets, but not so the concessionaires. Of six attractions managed by the California Concessions Company, only Captain the Equine Marvel was a great success.

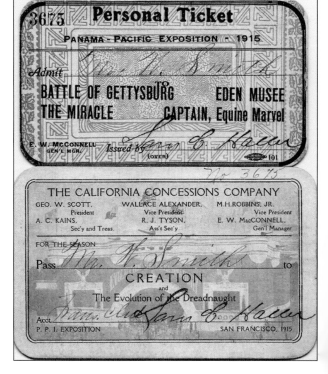

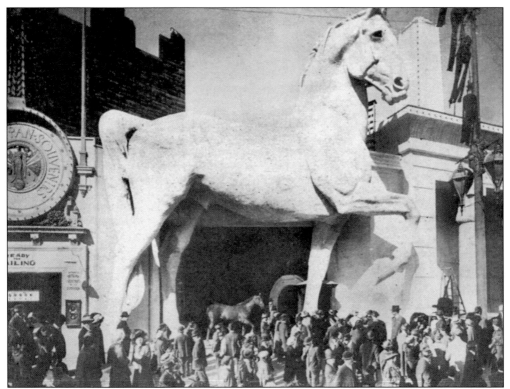

Named for the man commanding the USS *Maine* when it exploded in Havana Harbor, Captain Sigsbee the Educated Horse was one of the Zone's true stars. A nine-year-old chestnut, he matched colors; made change; played tunes by ringing bells; and counted out numbers selected by the audience. Fairgoers loved "the horse whose thinking makes the world think."

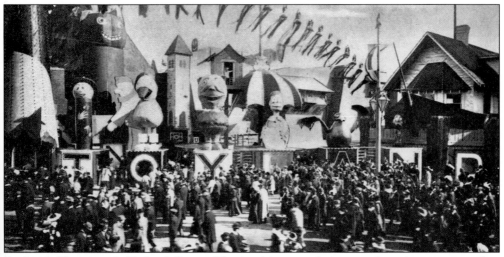

Frederick Thompson's Toyland Grown Up was 14 acres of games and stories exaggerated to epic proportions. Giant tin soldiers, alphabet blocks, Mother Goose characters—even Stephen Foster's Old Dog Tray—populated "The Wind Mill in Market Street," "Tango Town," fantastical castles, and much more. The dean of American amusement parks, Thompson had his greatest success with Coney Island's Luna Park, which opened in 1903.

Not everyone was amused by the 90-foot statue of a suffragette at the entrance to Toyland Grown Up. In California, the vote for women was narrowly approved only four years prior. Women were not enfranchised nationally for another five years. The exposition allowed the statue only after Thompson changed the name from *Panama Panklaine Imogene Equalrights* to *Little Eva*.

The Scenic Railway, the first completed Zone concession, opened for business on January 1, 1915, more than six weeks before the fair itself. Part sightseeing excursion, part roller coaster, patrons traveled through a themed environment of elaborate artificial scenery and dramatic lighting effects. L.A. Thompson, the concessionaire, known as the "Father of Gravity," built the first roller coaster in the United States at Coney Island in 1884.

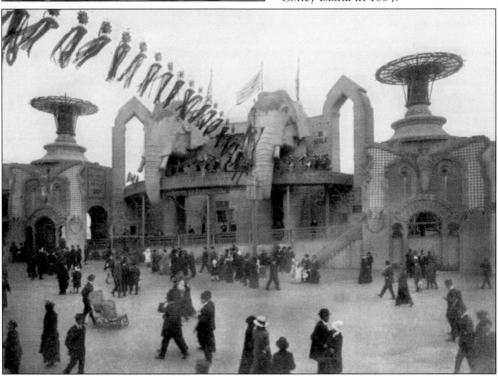

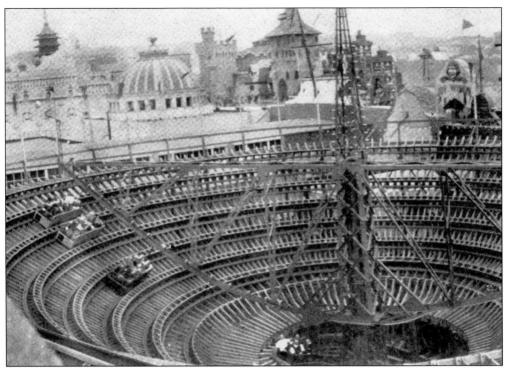

The Bowls of Joy was an exciting, though dangerous, ride. Seated in small roller-coaster cars, patrons sped around the inner surfaces of two inverted cones.

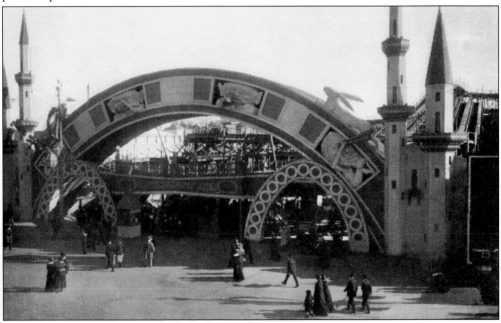

The popular Safety Racer featured two roller coasters that sped against each other. When the exposition closed, the attraction moved to Neptune Beach, the "Coney Island of the West" on Alameda, across the bay from San Francisco. The amusement park closed in 1939, and the next year a junk dealer bought the racer for $60.

The exposition itself sponsored the Miller brothers' 101 Ranch. A free show, it presented horse thieves, holdups, "Indian battles," and other "characteristic incidents of early frontier life." Unfortunately, it failed to attract many fairgoers. Expensive to run because of the cost to house and feed its performers—two- and four-legged—the exposition closed it early. The site remained mostly unused for the rest of the fair.

The exposition's official guide called the '49 Camp "a faithful presentation of life as they lived it in California in discovery days." Historical accuracy, however, cut it no slack from the selfless protectors of public morality, who condemned the alleged gambling, drunkenness, and general roguery that went on there. The exposition closed and reopened the attraction several times, and permanently shut it down two months before the fair ended.

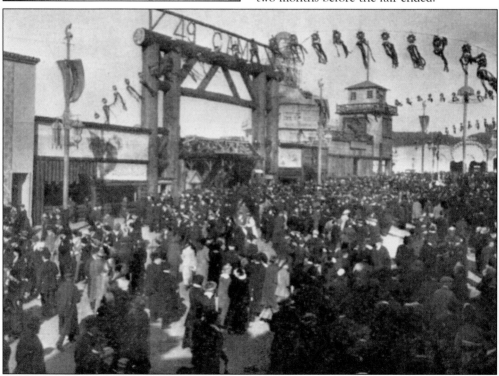

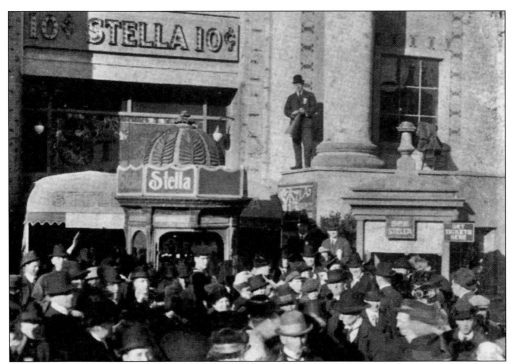

Stella was the belle of the ballyhoo, though she was only a nude portrait. Thanks to careful lighting and a simulated breathing effect, the "$50,000 marvel of the painter's art" seemed alive. Some 750,000 fairgoers, mostly men, paid 10¢ to look upon her with appropriate admiration.

The Shamrock Isle, the Zone's only European village, fared poorly; its folk singers and clog dancers failed to bring in many patrons. The Streets of All Nations, which replaced it, did better, perhaps because the new concessionaires added a raised platform to the entrance, allowing passersby to watch as others filed into the attraction.

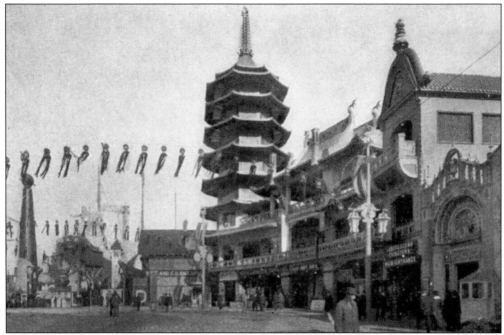

To the outrage of Chinese Americans, the Zone's Chinese Pagoda included "Underground Chinatown," which portrayed corrupt Chinese enticing whites to immoral vices. After protest, President Moore visited the attraction, then ordered it closed. It returned as "Underground Slumming," essentially the same attraction, without the demiworld set in Chinatown. Concessionaire Sid Grauman later opened a Chinese-themed movie theater in Hollywood.

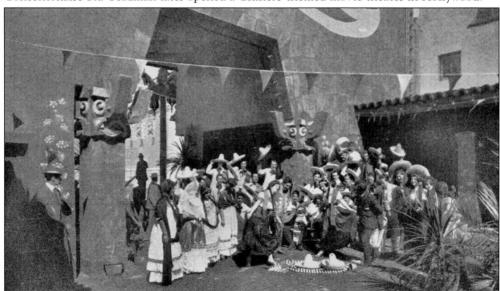

The Tehuantepec Village included a restaurant, a theater, musicians, and a community of costumed artisans who made and sold baskets, lace, jewelry, and more. Because of an American incursion into its territory the previous year, Mexico declined to have a pavilion at the exposition, but private American enterprise felt differently. Gilbert "Broncho Billy" Anderson, a hugely popular film star, was one of the investors.

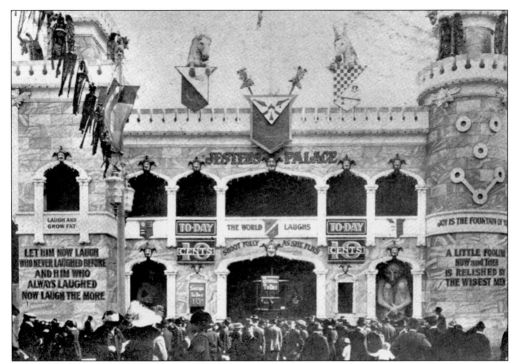

At the Jester's Palace, children of all ages could enjoy many traditional carnival and fun house attractions: mirrors, mazes, and mechanical figures. "Joy is the fountain of youth," said the jester. The fun and frolic cost 10¢.

The Zone offered numerous places to eat, from refreshment stands, to coffee parlors, to sit-down restaurants. The Alt Nuremburg offered one of the more extensive menus, as well as a live orchestra and dancing, for the enjoyment of patrons.

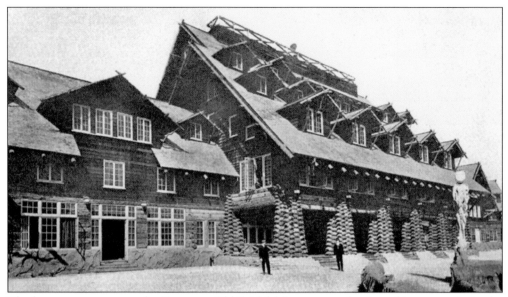

The largest restaurant on the Zone was Old Faithful Inn, a reproduction of its namesake in the Yellowstone National Park concession, which included a scale model of the natural wonder. The Exposition Orchestra, conducted by Max Bendix and others, played two concerts there daily. A favorite venue for dinners and banquets, it grossed over $330,000 for the season.

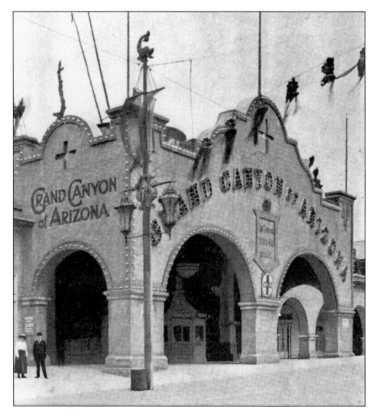

The Santa Fe Railroad sponsored the Grand Canyon of Arizona on the Zone. Panoramic models enabled fairgoers to experience a simulated 200-mile journey through the great gorge's waterfalls, painted desert, and trails.

Invited by the Santa Fe, some 20 Zuni and Hopi families lived in the little Pueblo Village built on top of the Grand Canyon building. Titled "The Life of a Vanishing Race," the attraction showed the "home life of this most ancient race of Americans which still observes the customs that prevailed among them when Columbus discovered America, even to the grinding of corn by hand for making bread."

At the Ostrich Farm, about 100 birds strutted their stuff while visitors waited to see the fowl stunts for which the "feathered fools" were famous. Even with an admission of only 10¢, not many fairgoers bothered about them and more than one was furloughed to the Vienna Cafe next door. The Alligator Farm did no better business, but fortunately for those performers, there was no restaurant nearby.

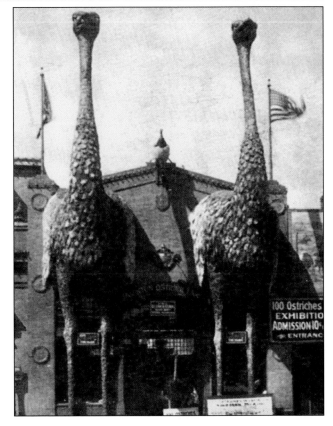

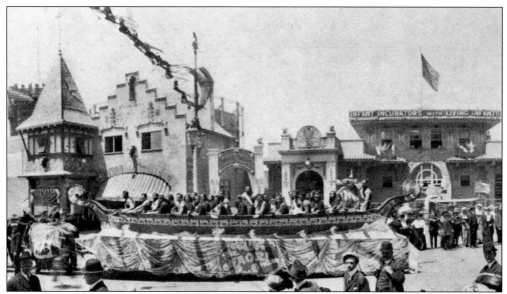

Because of its broad, flat, and long street, the Zone was the ideal place for the exposition to stage numerous parades and pageants. Here, Maori dancers ride a float that is just passing the Infant Incubators concession. Many of the parades were miles long.

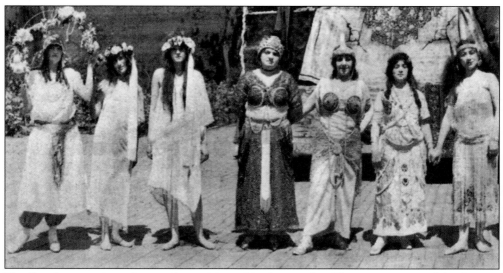

The Zone's entertainers frequently participated in the parades. The participation of the dancers from the Streets of Cairo, a popular world's fair attraction since the World's Columbian Exposition of 1893, added beauty and color to any event. Here, members of the troupe pose before a typically elaborate float.

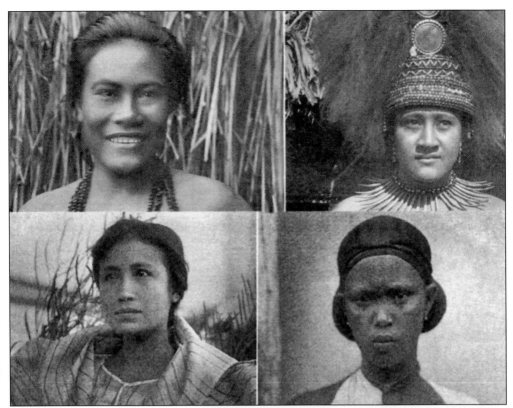

The Zone was the most culturally diverse area of the exposition, its inhabitants representing all parts of the world. Seen here are a Hawaiian hula dancer; a Samoan princess; a woman from the Philippines; and a Somali dancer, one of the very few at the fair from Africa. Maoris, Egyptians, Japanese, Native Americans, Chinese, and others also entertained in the Zone's attractions. Mexico, the Netherlands, and the United States were also represented.

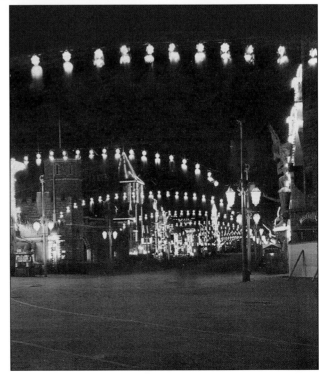

At night, the Zone took on a carnival atmosphere. While the rest of the exposition used muted colors and indirect lighting, the street favored bright white lights and stark illumination, with no subtlety.

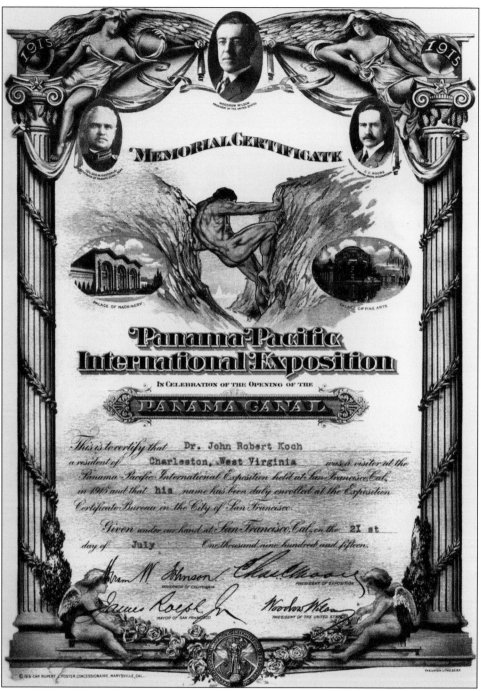

No visit to the exposition was complete without a souvenir, and the proud owner of a "Memorial Certificate of Visitation" could frame and display it in his or her home to the envy of friends and relatives. The certificate featured portraits of George Goethals, Woodrow Wilson, and exposition president Charles Moore; vignettes of the Palaces of Machinery and Fine Arts; cherubs; and assorted signatures. Available in three sizes for 25¢, 50¢ and $1, the largest was in full color.

Five

SPECIAL DAYS

Every day was a special occasion at the exposition. Named days honored everything from states, counties, countries, and people to child labor (May 28), aerial navigation (July 13), Buddha (August 3), and San Francisco composers (November 14). Fairgoers attended Baked Potato Day; Raisin Day; Non-Smokers' Protective League Day; Druids Golden Jubilee Day; Doll Day; Ripe Olive Day; and Guatemala Coffee Day, among many more. Almost a thousand conventions and congresses met in San Francisco, more than 120 specifically for women on topics ranging from child welfare to social hygiene and national suffrage. The number of invitations, programs, pins, ribbons, and other souvenirs was truly staggering.

The exposition hosted many firsts, many the result of the inventions that would shape the 20th century. Even before it opened, it was the site of the first indoor airplane trip and the first transcontinental telephone call. It was the first American world's fair opened by wireless telegraphy and the first to use motion pictures in its marketing. It was the first where fairgoers could ride in an airplane—three years before the beginning of airmail and more than a decade before commercial aviation. Visitors saw the first periscope exhibited in the United States; the first steam pyrotechnics; and the first indirect lighting. In addition, it was the first great American world's fair to not exhibit horse-drawn vehicles and the first to have automobile parking lots.

On January 25, 1915, the exposition was the western terminus of the first transcontinental telephone call when Alexander Bell (center) in New York called Thomas Watson at the fairgrounds. "That's an amazing invention," Pres. Rutherford Hayes said years earlier, "but who would ever want to use one of them?" Who indeed. By 1915, Americans averaged 40 telephone calls per year.

The PPIE was the first grand American exposition to have automobile racing. The first important competition, the Grand Prix, took place on February 27, just a week after it opened. Spectators could buy grandstand seats, or they could stand along the route through the fairgrounds to watch drivers roar past at speeds up to 50 miles an hour. At the wheel of a 5.6-liter Peugeot, Dario Resta took first place, completing the 400-mile, rain-soaked and extremely muddy course in 7 hours, 7 minutes, and 57 seconds, averaging a little more than 56 miles per hour. He also won the fair's 300-mile Vanderbilt Cup race on March 6. On the dry course, he averaged 67.5 miles per hour. The year after the fair, he won the Indianapolis 500.

The President and Board of Directors
of the
Panama-Pacific International Exposition
have the honor to announce
the formal dedication of the Exposition
by
The Vice-President of the United States
in the
Court of the Universe, Exposition Grounds
on Wednesday afternoon, the twenty-fourth of March
nineteen hundred and fifteen
at two o'clock

When presented in the Court of the Universe
this card will entitle you and your family to seats in the
reserved section in front of the speakers' platform

Although the exposition opened on February 20, it was not formally dedicated until March 24, when Vice President Thomas Marshall visited the fairgrounds for that purpose. More famous for summing up the nation's troubles by saying, "What this country needs is a good 5¢ cigar," he characterized the fair as "this marvel of the Republic, upon the shores of the sunset seas."

Special events and special occasions, of course, required daily parades to and across the fairgrounds. Here, marines march in review past Vice President Marshall on Dedication Day, when "men of every age and every clime behold the noonday of the world's accomplishment."

AUTO DAY

AT THE

Panama-Pacific International Exposition

Wednesday, July 15, 1914

LINE OF PARADE
Starting at Ferry at 1:30 P. M.

Out Market Street to Van Ness Avenue. Out Van Ness Avenue to Lombard Street. Out Lombard Street to Baker Street entrance to Fair Grounds.

Parade will be led by—
FIRST DIVISION—Grand Marshall William T. Sesnon. Chief of Police White, escort of police officers in new automobiles; Mayor James Rolph Jr., officials auto industry; President Charles C. Moore, Exposition; Board of Supervisors, City and State Officials, Exposition Officials, Employees of the Panama-Pacific International Exposition, City and County Delegations.
SECOND DIVISION—Fall in line at Steuart street—Overland cars.
THIRD DIVISION, Spear Street—Packard, Pierce, Winton, Lozier, Locomobile, Peerless, Hudson, Oldsmobile, Hupmobile.
FOURTH DIVISION, Drumm Street—All Cyclecars.
FIFTH DIVISION, Main street—Buick.
SIXTH DIVISION, Davis Street—Oakland, Regal, Maxwell, White, Kline, Velie, Mitchell.
SEVENTH DIVISION, Pine Street—American, Cole, Stevens, Pathfinder, Interstate, Marmon, Stutz, S. G. V., Pope, Touraine, Havers, Apperson, Franklin, Abbott, Auburn, Autocar, Chandler, Mercedes, Mercer, Stanley, Westcott.
EIGHTH DIVISION, Beale Street—Jackson, Cadillac, Reo, Metz, Pacific, Kissel Kar.
NINTH DIVISION, Front Street—Jeffery, Chalmers, National.
TENTH DIVISION, Fremont Street—Studebaker.
ELEVENTH DIVISION, First Street—Ford.
TWELFTH DIVISION, Battery Street—All trucks.
THIRTEENTH DIVISION, Second Street—All electrical vehicles.

After the ceremonies there will be the unfurling of the largest flag in the world in dome of Palace of Transportation. This flag was loaned by the Sacramento Camp of Spanish War Veterans. Simultaneous with the unfurling of the flag scores of white pigeons will be released from a gigantic liberty bell hung under the flag.

For Automobile News of All Kinds Read The

San Francisco Examiner
—Monarch of the Dailies
Supreme in Everything

KISSEL KAR

WHEN you ride in a Kissel Kar you are conscious of neither motion nor motor — it's "comfort construction" absorbs the jar of the road and minimizes engine vibration and noise. *Have you seen the new Two-Door Kissel Kar with its yacht-like lines.*

FOUR AND SIX CYLINDER
CARS IN ALL BODY TYPES

Kissel Kar Trucks—Six Sizes
1500 Pounds to 6 Tons

Pacific Kissel Kar Branch
GEARY AND VAN NESS
OAKLAND SAN FRANCISCO LOS ANGELES

July 15 was Auto Day, which featured a caravan of cars from Market and Van Ness to the fairgrounds. The automobile club publicized the event widely, and some 5,000 vehicles participated. Most were gasoline powered, but one division was reserved for electric vehicles. Trucks also took part. Of the more than 50 different makes represented in the parade, only four are still produced. The Kissel Kar, Locomobile, Oakland, Pacific, Hupmobile, Pathfinder, Pierce, Oldsmobile, and all the rest have been relegated to memory and museums.

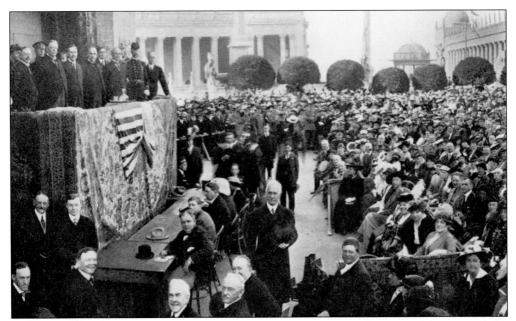

Taft Day was September 2. Always popular in San Francisco, the former president toured the grounds, visited the state buildings and foreign pavilions, and greeted thousands of fairgoers from the podium in the Court of the Universe. Here he is second from the left in the front row. Exposition president Charles Moore stands to Taft's left.

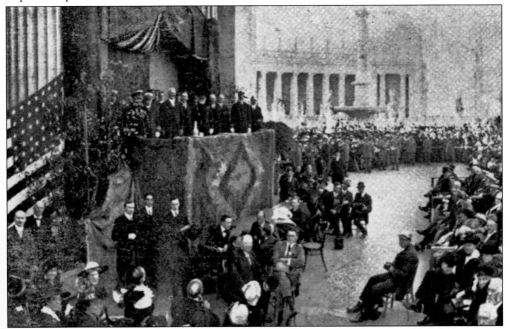

Goethals Day, September 7, honored "the man that had done what would probably stand throughout the 20th century as that century's greatest single work." When his job as superintendent of construction ended, a grateful nation offered him the Canal Zone's governorship—at a one-third reduction in salary. Standing to the right of exposition president Charles Moore, he spoke to fairgoers gathered in the Court of the Universe.

Film stars Roscoe "Fatty" Arbuckle and Mable Norman not only visited the exposition, they made a feature film about it, copies of which still exist. Here, San Francisco mayor James Rolfe gives them a tour around the new city hall, then under construction. Others who visited the fair included Charlie Chaplin, Helen Keller, William "Buffalo Bill" Cody, Lotta Crabtree, Eddie Rickenbacker, and future president Franklin D. Roosevelt.

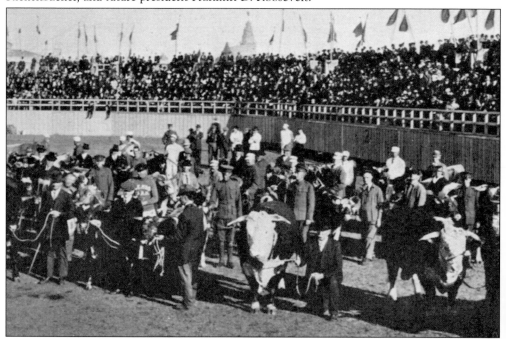

Humans were not the only ones to have parades at the PPIE. The Livestock Day Parade on October 23 attracted a sizeable audience to see the pride of numerous county and state fairs. Other special events included the International Egg Laying Contest; the Milk and Cream Show; and sheep-shearing and wool-grading contests. Wool gathering was noncompetitive.

No special day at the fair was complete without special ceremonies and an official photograph of the participants. Most honored organizations chose to be remembered by very popular, very large, panoramic photographs, four or five times longer than they were wide. Above, some of the members of the Commonwealth Club of San Francisco pose for their group portrait. Below is part of the audience for New England Day ceremonies, April 19, 1915, the anniversary of the Battles of Lexington and Concord. The colonial drum and bugle corps would return in July to welcome the Liberty Bell.

The exposition hosted the largest horse show held in the western United States to that date. Between September 30 and October 13, competitive judging was held for both breeding classes and performance classes of horses, as well as mules, jacks, and jennets. The PPIE also was the first to have horse racing, which included harness-race meets in June and October. The events attracted large and enthusiastic crowds.

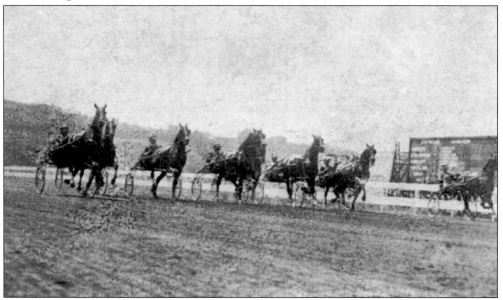

The numerous events of the horse show included four-in-hand and tandem driving, exhibitions of gaited saddle horses, polo competitions, and an international military tournament.

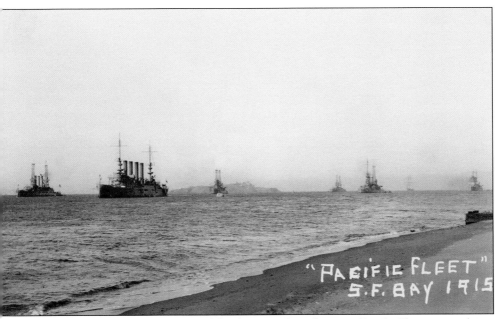

It was a joyous day for the exposition and for the city when the great Pacific Fleet steamed into San Francisco Bay for an extended visit. Boat races between the naval crews followed and drew large crowds of spectators.

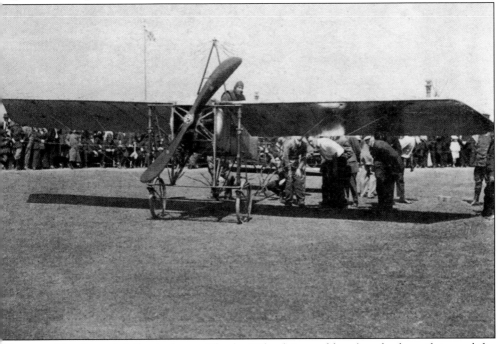

The exposition hosted daily air shows. Charles Niles (pictured here) and other pilots used the north lawn to take off and land. For the first time at an American exposition, the public could enjoy an airplane ride—or at least experience one. Aviation was only 12 years old in 1915, so even seeing a plane was a novelty for many people. Commercial air travel was still more than a decade away.

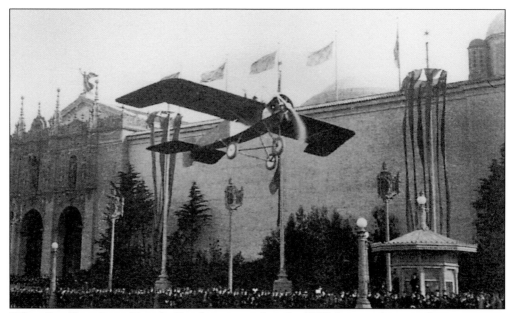

When San Franciscan Lincoln Beachy appeared at the PPIE, he was the most famous aviator in the world. The "father of aerobatics" and the first American to perform a loop-the-loop, he died at the fair while demonstrating an experimental monoplane. A plaque on the old fairgrounds honors him.

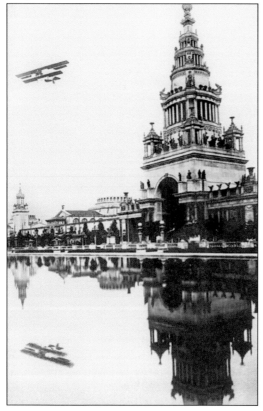

Following Lincoln Beachy's death, Art Smith became the world's premier aerial acrobat, amazing crowds with his loops, side dips, and somersaults. New records were set throughout 1915: highest elevation reached; fastest speed at 150 mph; and longest flight (1,400 miles in 26 consecutive hours). Sadly, the year also saw the first aerial bombardment of a civilian population.

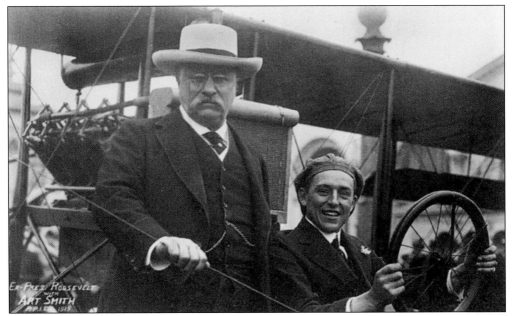

Like many other visitors to the exposition, Pres. Theodore Roosevelt sought out famed aviator Art Smith. He was the first president to fly—on October 11, 1910, just a year and a half after leaving office; his cousin Franklin became the first president to use an airplane while in office.

The Vikings landed at the exposition's Yacht Harbor on June 3—Norway Day. In traditional Norse clothing, the chorus and Norwegian societies led the procession to Norway's pavilion for the formal ceremonies and a program of music.

Of all its distinguished visitors, the Liberty Bell may have been the exposition's most cherished. When San Francisco first invited it, Philadelphia declined to send it, so October 11, 1912, became Liberty Bell Day and students throughout the city signed petitions to Philadelphia's mayor requesting the historic icon. Eventually, more than a quarter-million schoolchildren throughout the state wrote, printed, or otherwise added their names to the lists.

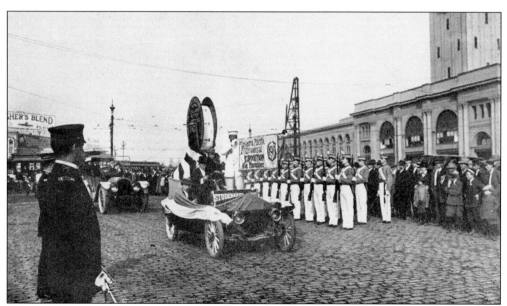

Escorted by mounted police, the Columbia Park Boys Band, the California Grays, city officials, and many others, the petitions—pasted end to end into a single document spanning two miles—left San Francisco on Thanksgiving Day, 1912. They arrived in Philadelphia on December 7 and were paraded through the streets before being taken to the mayor, who finally agreed.

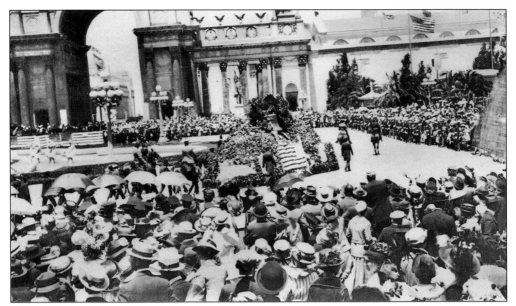

The bell reached San Francisco on July 17, 1915, after a goodwill tour across the country. Thousands greeted it at the Ferry Building and along its route to the fairgrounds. Once there, it was displayed in the South Gardens, where the official welcoming ceremony was held.

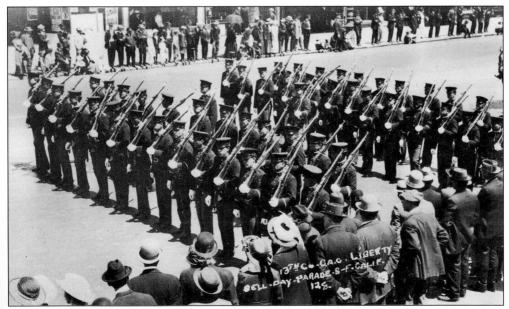

After the ceremony, the bell became part of long parade to the Pennsylvania Building, where it took up residence for the remainder of its stay. Members of the 13th Company of the Coast Artillery Corps, headquartered in Los Angeles, marched not only with precision, but with their rifles.

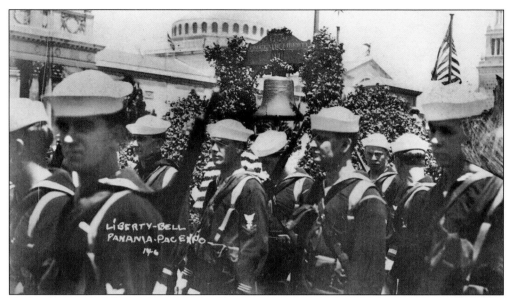

Numerous military battalions, units, and companies marched with the bell from the South Gardens to the Pennsylvania Building. In those days, people were allowed to touch the beloved artifact if they wished.

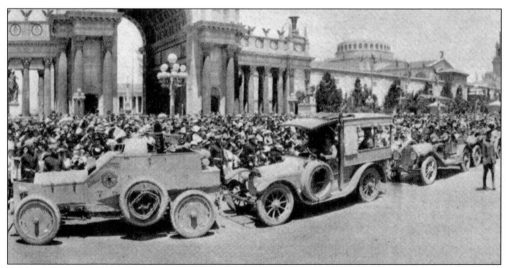

Among the contingent protecting the Liberty Bell on its way to the Pennsylvania Pavilion were Cadillac armored cars, never before seen on the West Coast.

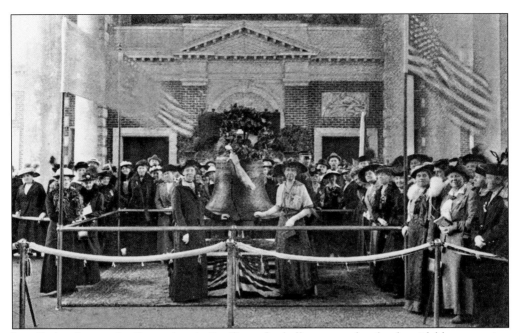

Installed at last in the Pennsylvania Pavilion, the bell came under the formidable protection of the Daughters of the American Revolution, whose Philadelphia sisters had bitterly opposed sending it to San Francisco. During the exposition, the organization had its headquarters in the Grand Canyon concession on the Zone.

So powerful were both the symbolism and the reality of the bell that everyone, it seemed, wished to be photographed with it. The relic remained at the exposition until November 10 when, with pomp and ceremony, it departed to San Diego. After a brief visit there, it returned to Philadelphia, having traveled some 20,000 miles round-trip. It has not ventured forth since.

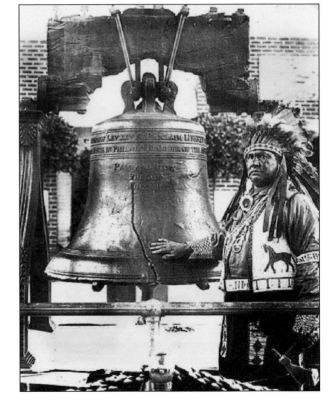

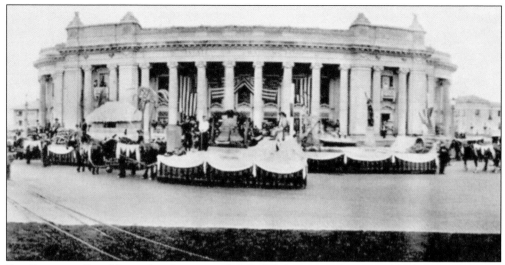

San Francisco Day, November 2, attracted 348,472 fairgoers, the second-highest attendance. The crowd in the South Garden seemed barely able to move, and other places on the fairgrounds were equally crowded. One highlight of the day was the parade of floats telling the story of the city's past and present.

One reason for the enormous turnout, in addition to public pride and enthusiasm for the fair, was the large number of complimentary tickets given to company employees and shop patrons—and their children. The central portion, with its line drawing of the Palace of Fine Arts, became a souvenir of the celebration.

Closing Day, December 4, 1915, brought 459,022 people to the fairgrounds, more than had attended any public gathering in the western United States. Events included the 100-mile Exposition Cup automobile race, but most came to see the fairgrounds one final time in all its glory.

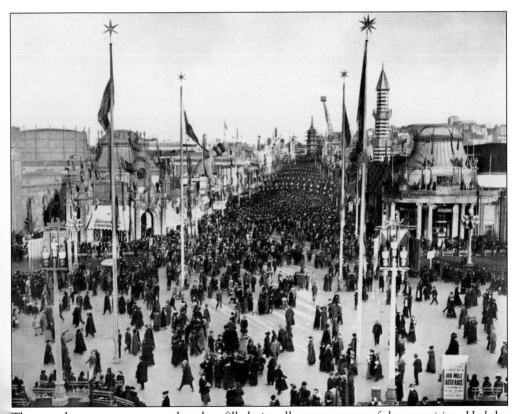

The crowds were so enormous that they filled virtually every corner of the exposition. Had the Zone, looking east toward the Van Ness entrance gates, attracted even half as many people at other times as filled the street on Closing Day, many of the concessions might have done better.

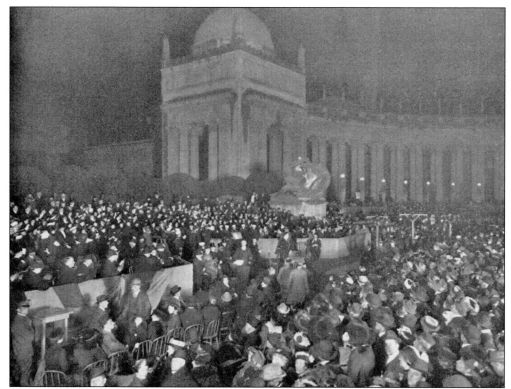

Formal events took place in the Court of the Universe. In the morning, the Philippine Constabulary band played there for an estimated 150,00 people, and crowds gathered throughout the day.

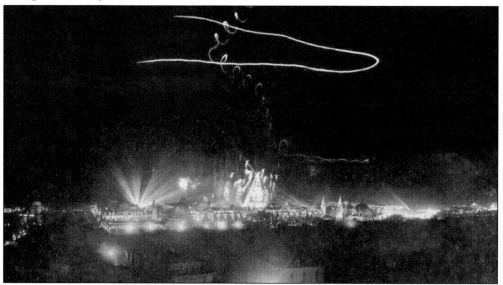

As midnight approached, lights slowly dimmed throughout the fairgrounds, the last of them on the figure of Descending Night. A bugler in the Tower of Jewels played taps. High overhead, aviator Art Smith did loop-the-loops in his airplane for the last time. No one was asked to leave; some remained until after 4 a.m., without vandalism or destruction of any property.

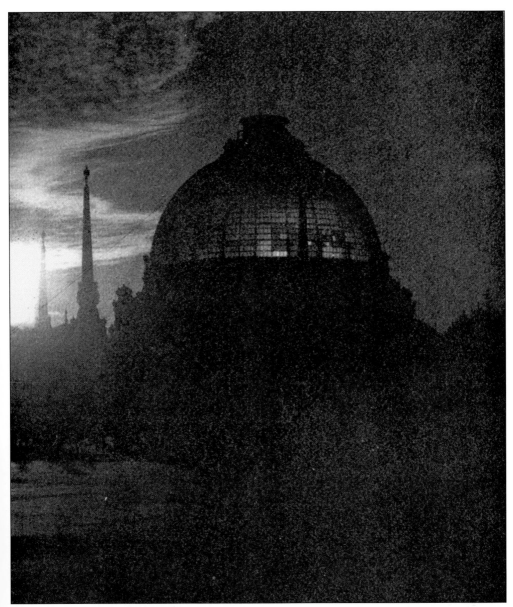

With the exposition's lights extinguished, the Palace of Horticulture and its surroundings sit in a darkness from which they will never emerge. Built at a cost of more than $340,000, it was scrapped for $5,000. Within a year it was gone—the great South Garden scraped clean of vegetation, its reflecting pool drained, dismantled, and filled. For a while, though, it would still create a romantic silhouette against the night sky. Wrote San Francisco poet George Sterling:

> The Future is our kingdom, and although
> Our hands unbuild the city they have built,
> Yet no blood is spilt
> No swords uplifted for a nation's woe.
> And though the columns and the temples pass
> Let none regret; let no man cry "Alas!"

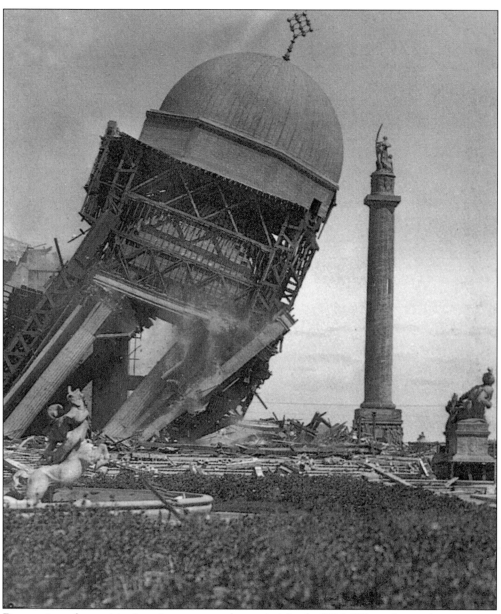

Destruction of exposition's major structures began in March, 1916. When the southwest corner of the Court of the Universe was dynamited, the Tower of Jewels had already been razed, although the Palace of Transportation, across the plaza, still remained standing. Contractors were not interested in dismantling the large wooden exhibit halls, so the Exposition Company did the work itself.

Six

THE END OF THE TRAIL

Demolition began almost immediately after the buildings were vacated. Furniture, equipment, fixtures, plants, and the buildings themselves—everything was priced to sell or was auctioned. The signature Tower of Jewels, which cost more than $413,00 to build, was sold to salvagers for $9,000. Where salvage operations for lumber fell below 1,000 board feet per day, per worker; the wood was burned, considered not worth the cost of handling. The exposition netted about $353,000 from these sales, about the cost of building the Palace of Mines and Metallurgy.

Some of the smaller buildings were moved to other locations. The Wisconsin and Virginia Buildings were relocated to Marin County. The Ohio Building went to San Mateo County, where it survived until the 1950s. The Japanese Pavilion was to move to Lobos Square, but collapsed during transport. The Oregon Building, on Presidio land, was used for a time as a clubhouse for soldiers, but it, too, is gone.

On December 19, 1915, more than 10,000 people watched Art Smith's aerial acrobatics one last time. That year, the city's annual Christmas tree festivities were held in the Court of the Universe on Christmas Day. Between January 1 and May 1, 1916, the San Francisco Art Association exhibited the work of some 800 artists in the Palace of Fine Arts. A year after opening day, a "One Year After" Day attracted more than 45,000 participants. The California Building hosted the Artist's Ball on April 29, and thousands attended. The last paid admission wasn't received until November 15, 1916. By then, demolition was well under way.

The Preservation League tried to raise enough money to save at least the California Building, the marina, the Column of Progress, and the Palace of Fine Arts, which was, according to contemporaries, "in many respects the most beautiful building in the world, the most inspiring setting possessed by any art museum."

The Exposition Company donated the California Building to the State Normal School Trustees, but ensuing legal and financial complications doomed the project, and the structure was razed. The company decided to buy the property it did not own that formed the marina, then conveyed it to the State of California, which preserved it until the City took possession. The Column of Progress was torn down after a decade to accomodate automobile traffic on the new Marina Boulevard. Only the Palace of Fine Arts remains on the old fairgrounds.

The Arch of the Rising Sun, crowned by the immense sculpture group *Nations of the East*, was dynamited toward the end of May 1916. The figures all stayed in place until almost to the ground, where they smashed to bits. An identical fate came to its counterparts across the Court of the Universe, the Arch of the Setting Sun and *Nations of the West*.

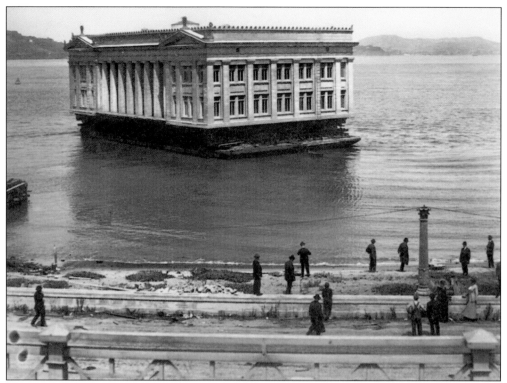

The Ohio Building, a replica of that state's dignified capitol and a fine example of Greek Revival civic architecture, was bought for $1,000 and towed to San Mateo County, where, for a time, it became the popular Babylon Club. During World War II, it was used by an airplane parts company. In 1956, it was burned down to make room for an asphalt plant.

Very little of the fair's sculpture was salvaged, even when offered to anyone who would cart it away. The maquettes, however, were saved, placed into some 200 crates, and given to the City. Their whereabouts today are unknown. A few sculptors received permission from the exposition, which held the copyrights, to make smaller versions in permanent materials; these included Calder's *Star Maiden* and Weinmann's *Ascending Day* and *Descending Night*.

Almost all of the exposition's murals survived the end of the fair and were carefully removed and conserved. The eight done by Frank Brangwyn, one of the few artists not to journey to San Francisco to work—he also received the highest fee—were installed in Herbst Theater, where they remain on view. *The Windmill*, seen here, is one of two depicting the ancient element of air; others represent fire, water, and earth. With rare exception, the rest are in storage, most not on public view since 1915.

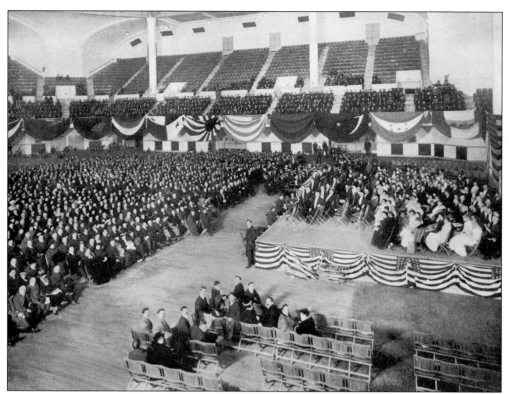

The PPIE built Exposition Auditorium in San Francisco's new civic center as a permanent facility for some $1.3 million. During the fair, it was used for conferences and conventions, as well as some entertainments. On December 30, 1916, about 3,000 people witnessed its transfer to the City when exposition president Charles Moore presented a golden key to Mayor James Rolfe. It has been in use ever since.

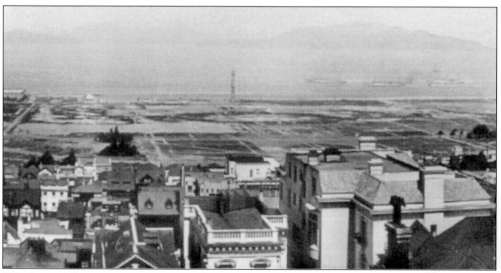

Wreckage and restoration was essentially complete by February, 1917. Flat, graded property was returned to its owners, suitable for subdivision and development. The Exposition Company was formally dissolved in August, 1920, a little over 10 years after its formation.

During the 1920s, the old fairgrounds not part of Fort Mason or the Presidio became a new neighborhood, the Marina District. Today, this vibrant community is one of the most beautiful in San Francisco.

Once the exposition's north lawn, the Marina Green was used by the fair's pilots. It then served as San Francisco's first air field before being transformed into the neighborhood greenspace that is enjoyed today by walkers, sunbathers, kite fliers, friends, and sweethearts.

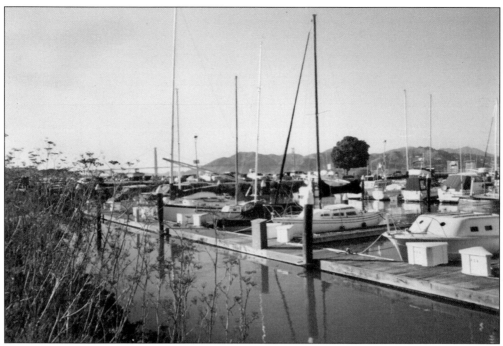

The Yacht Harbor, since expanded, was another gift to San Franciscans from the exposition. Now home to more than 700 vessels of many types, it has been in use since it opened in 1914.

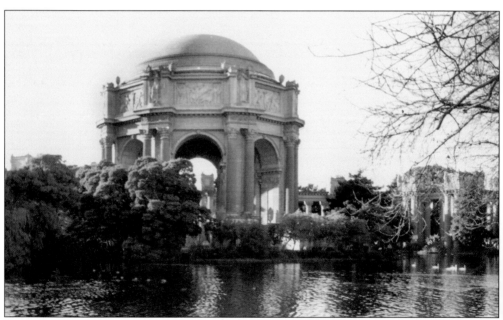

Used since the exposition for indoor tennis courts, a motor pool, a warehouse, a telephone directory distribution center, and a fire department, the Palace of Fine Arts was rebuilt in the 1960s and now houses San Francisco's Exploratorium. It has been a landmark since it was built in 1914 and has become the fair's true monument and most beautiful legacy.